Central OREGON

View from the Middle

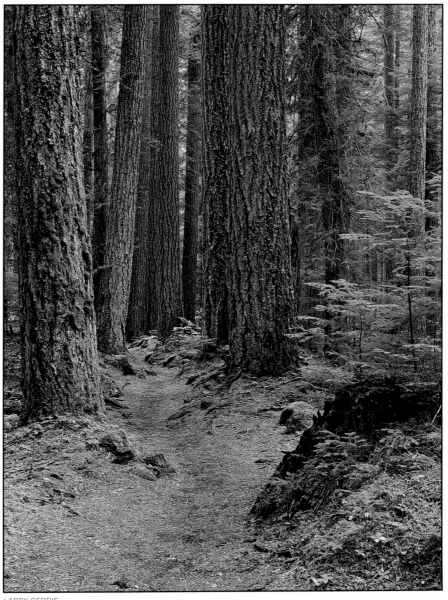

LARRY GEDDIS

by Christine Barnes

AMERICAN & WORLD GEOGRAPHIC PUBLISHING

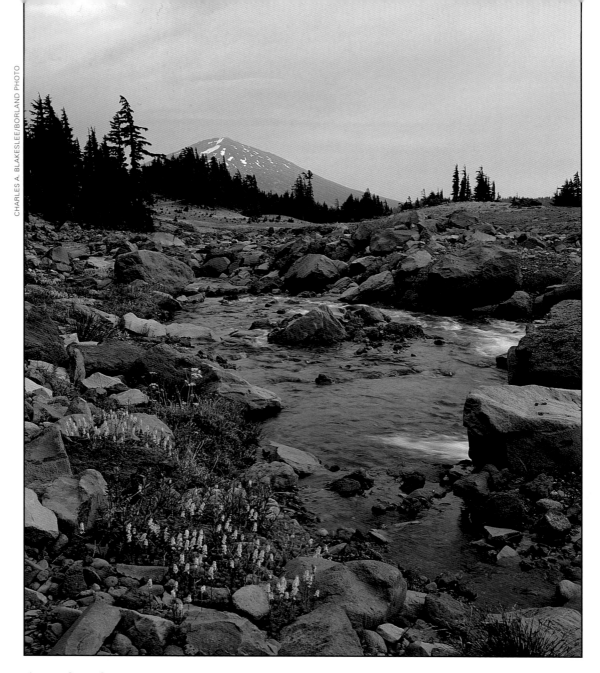

CHARLES A. BLAKESLEE/BORLAND PHOTO

ABOVE: SODA CREEK MEANDERS ALONG A ROCKY SLOPE AS MOUNT BACHELOR TOWERS IN THE DISTANCE.

FACING PAGE: PROXY FALLS IN THE THREE SISTERS WILDERNESS DISPLAYS ITSELF IN ETHEREAL SPLENDOR.

TITLE PAGE: PAMELIA LAKE TRAIL LEADS THROUGH A FOREST OF OLD GROWTH DOUGLAS-FIR AND HEMLOCK IN THE MOUNT JEFFERSON WILDERNESS.

FRONT COVER: A FAVORITE CENTRAL OREGON LANDSCAPE DOMINATED BY MOUNT BACHELOR WITH TODD LAKE MIRRORING A DRIFTING CLOUD. LARRY GEDDIS

BACK COVER: A HOT AIR BALLOON APPEARS ALMOST TOYLIKE AGAINST SMITH ROCK STATE PARK'S NATURAL SPECTACLE. DAVID M. MORRIS

Text © 1996 Christine Barnes
© 1996 American & World Geographic Publishing

This book may not be reproduced in whole or in part by any means (with the exception of short quotes for the purpose of review) without the permission of the publisher.

Write for our catalog:
American & World Geographic Publishing,
P.O. Box 5630, Helena, MT 59604.

Library of Congress Cataloging-in-Publication Data
Barnes, Christine
 Central Oregon : view from the middle / by Christine Barnes.
 p. cm.
 Includes index.
 ISBN 1-56037-087-4
 1. Oregon--Description and travel. I. Title.
F881.2.B37 1996
917.95'80443--dc20 95-52320

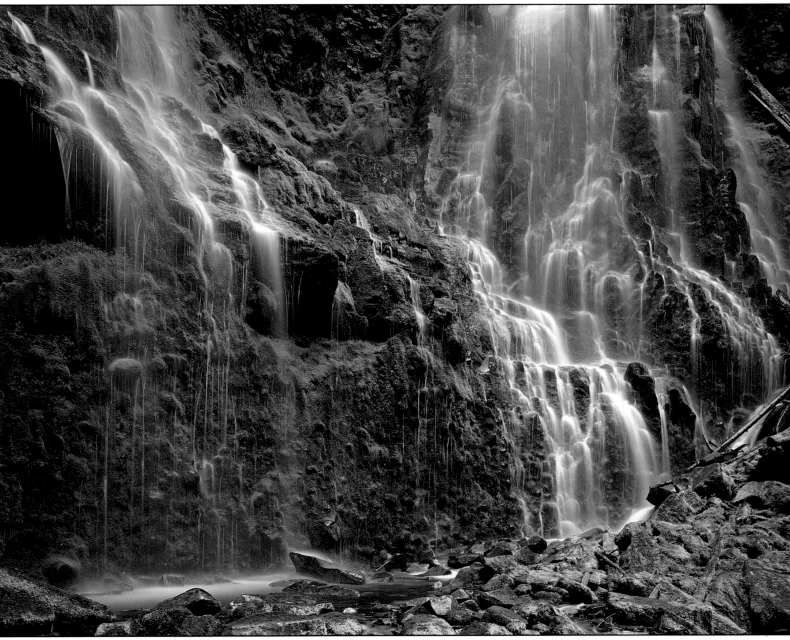

To Jerry
For discovering this place and making it our home,
and Melissa and Michael for sharing in the adventure.

A special thanks to: Diane Sparkling, my enthusiastic side-kick on many "field trips"; my Bend neighbors and friends, Karen Swirsky, Nils Eddy, Gary Beaudoin, Jane Williamson and Barrett Best for their encouragement and information; and my extended family. Expert readers, Keith Clark, Larry Chitwood and Charles "Jody" Calica, to name a few, were generous with their time and expertise.

Thanks also to: Bend Chamber of Commerce; A.R. Bowman Memorial Museum, Prineville; *The Bulletin*; Business Development Center, Bend; Central Oregon Economic Development Council, Inc.; Central Oregon Llama Association; Central Oregon Welcome Center; Confederated Tribes of the Warm Springs Reservation; Deschutes County Historical Society; Deschutes County Library; Deschutes National Forest; High Desert Museum; Jefferson County Historical Society and Museum; John Day Fossil Beds National Monument; Madras Chamber of Commerce; Mt. Bachelor Ski Area, Corporate Headquarters; The Museum at Warm Springs; Prineville Chamber of Commerce; Redmond Chamber of Commerce; Regional Arts Council of Central Oregon; Sisters Chamber of Commerce.

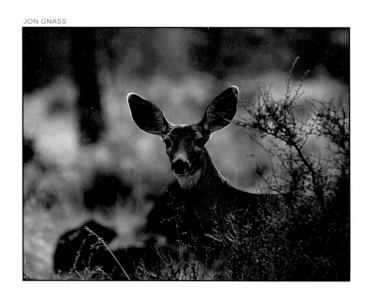

JON GNASS

Contents

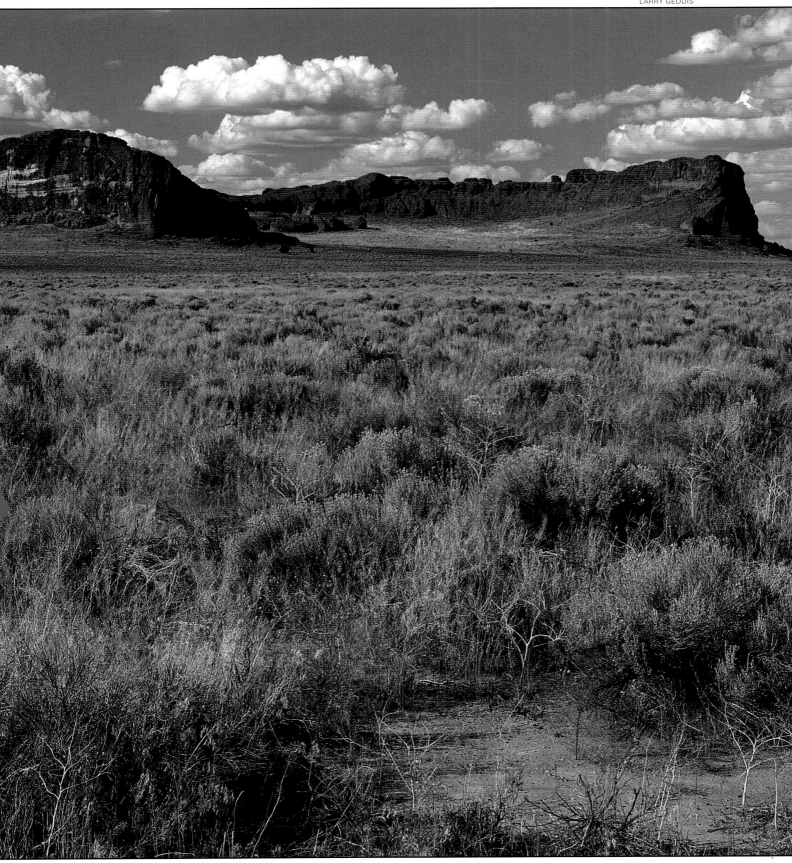

ABOVE: SAGE AND RABBITBRUSH CARPET THE LAND AROUND A DRAMATIC VOLCANIC FORMATION, FORT ROCK, IN LAKE COUNTY.
FACING PAGE: WHITETAIL DEER, DESCHUTES NATIONAL FOREST.

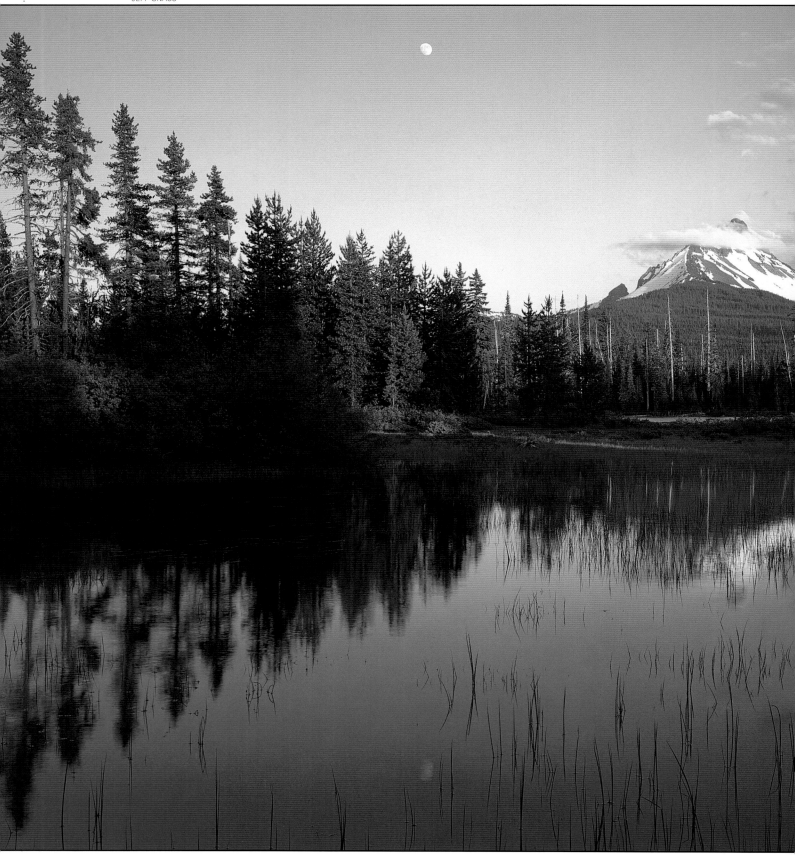

ABOVE: THE MOON AND THE FOREST REFLECT AT SUNSET AT BIG LAKE ALONG THE MCKENZIE-SANTIAM PASS LOOP SCENIC BYWAY IN THE WILLAMETTE NATIONAL FOREST.

FACING PAGE: WILDFLOWERS DECORATE CANYON CREEK MEADOW IN THE MOUNT JEFFERSON WILDERNESS.

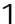

JEFF GNASS

What is Central Oregon?

here are moments in Central Oregon that simply make you stop. You pull the car over to the side of the road, come to a wobbling halt on your bicycle or quit pushing the shopping cart as you leave the grocery store. You stop because the setting is overwhelming; you have to take a long hard look, then count your lucky stars that you're here. Stop and take a deep breath of clear clean air. Stop and wonder how rainbows happen when it's snowing. Stop and chuckle at the sight of moonscape-like cinder cones or get misty-eyed at the silhouette of the Cascade Range. Stop to let a herd of deer or a covey of quail pass by.

And that may be the beauty in the beauty. People *remember* to stop and appreciate what is around them. They listen for the sounds of spring and fall or the feel of winter. They soak in the sun and worship the snow.

They are here, smack in the middle of the state, east of the Cascade Range in a region where the largest city, Bend, once was dubbed by Oregon's Governor Neil Goldschmidt as being in: "the middle of nowhere."

But "nowhere" is definitely "somewhere." Central Oregon encompasses three counties (Deschutes, Jefferson, and Crook), five cities (Bend, Sisters, Redmond, Madras and Prineville), another handful of towns, portions of the Cascade Range, seven rivers, fifteen good-sized lakes and four reservoirs. There are more than 125,000 residents, and 3.5 million tourists think they've discovered it each year.

The canvas where all this is painted was created about 3 million years ago in volcanic convulsions that resulted in the mountains, rivers, lava flows, and jutting volcanic ash canyons that twist and merge and make this region a wild yet serene place.

Indigenous people hunted and gathered berries, but early settlers bypassed this swatch of land. Towns took hold at the turn of the 20th century, and boomed with the growth of the timber industry. Yet the region's profound natural beauty stayed a

7

secret to the rest of the country for years. Tourism and real growth began during the "leisure era" of the 1960s, when people started to think about the quality of their lives. Choked by smog, surrounded by crime, inundated by swarms of people as population centers mushroomed, Americans discovered the great outdoors.

What they found in Central Oregon was a trove of geological wonders created in the violence of volcanic eruptions: Ice Age remnants, prehistoric memorials, cinder cones, lava flows and crystal clear lakes; volcanic mountains set against intensely blue skies—snow-covered and fog-shrouded; mystical forests buttressed against the High Desert expanses and the delicate alpenglow of winter dawn and dusk.

And because they were human, they longed to be part of it. Like the farmers before them who found solace along the banks of the Metolius River after harvest, they came. They pitched tents then built homes. Mount Bachelor Ski Resort, destination point resorts, more camp grounds, hiking and biking trails blossomed. People scaled sheer cliffs of volcanic rock, rushed in rafts and kayaks down tumbling rivers cut through layers of basalt. They saddled up horses, powered up snowmobiles, strapped on skis and snowshoes or simply laced up hiking boots. They wanted to see it, live it, experience it all.

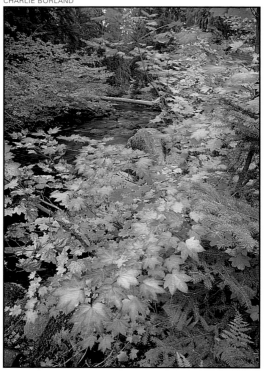

AUTUMN ON THE SANTIAM RIVER.

To service those needs, little towns like Bend, Redmond, and Sisters opened their arms. Malls, motels, gas stations, shops and restaurants reproduced faster than a hatch of insects on the Deschutes River. Boom.

To people still flowing into Central Oregon, boom isn't bad. And to many locals, the growth and the economic improvement that came with it have been welcome. Others wonder what this prized region will be like in the next century.

While the area has recently expanded airport service in centrally located Redmond, it is not always an easy place to get to. Travelers who venture to the sunny side of the mountains want it left alone once they discover the clean air, sunny weather, and scenery to celebrate. Portlanders, seeking respite from the rain, cast their eyes about and catch 360-degree panoramas in the High Desert.

Situated 160 miles from Portland, 490 miles from San Francisco and 318 miles from Boise, Idaho, highway access to Bend is still limited to two-laners except for the stretch of Highway 97 at each entrance to Bend. Amtrak leaves passengers in Chemult, 60 miles south of Bend, and while it can be a charming trip, the arrival and departure times are as erratic as the geological wonders of the area. All of this makes discovering Central Oregon more of an adventure to tourists and newcomers, and permits residents their well-earned smugness that this is indeed a very special place.

To the west is the lush Cascade Range, much of it in the Deschutes National Forest, with a profusion of stunning volcanic peaks. The forests feed the timber industry and nature lovers alike.

The hills and highlands east of the Cascades are a jumble of jagged black lava flows, waterfalls, cinder cones, buttes, acres of trees, and rivers that cut through the changing scenery. As suddenly as the mountains seem thrust up to the west, the High Desert, a world of grasslands, sagebrush and highly eroded bluffs, spans to the east.

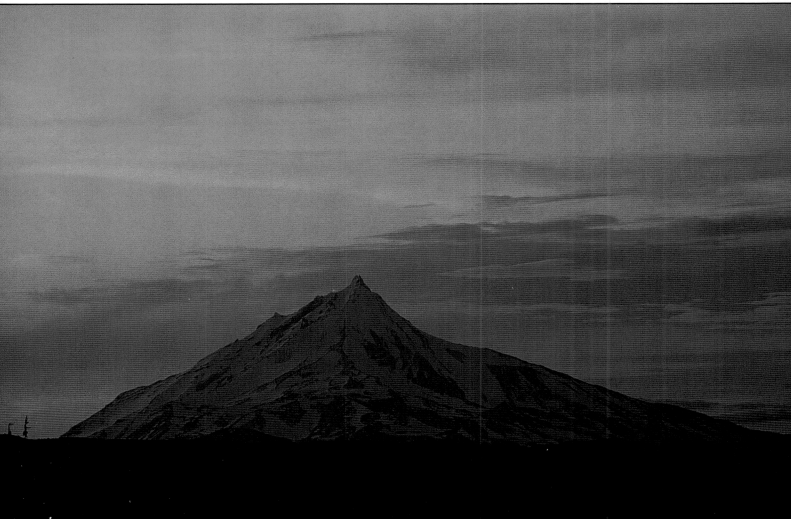

MOUNT JEFFERSON, WITH AN ELEVATION OF 10,497 FEET, IS OREGON'S SECOND-TALLEST MOUNTAIN.

To the south is one of Oregon's largest Ice Age volcanoes, the Newberry Crater, also one of the newest national natural landmarks. Lava Cast Forest, the Lava River Cave and the easily recognized Lava Butte also dot the landscape.

The Warm Springs Indian Reservation, owned and operated by the Confederated Tribes of the Warm Springs Reservation, is to the north. Within its boundaries are Kah-Nee-Ta Resort and the Museum at Warm Springs, one of the few museums in the country—and the only one in Oregon—featuring only Native American history, culture, and art.

Central Oregonians like to boast of 280 days of sunshine, a contradiction to the stereotype of the rainy Northwest. The climate is predominantly "high desert" with summer temperatures in the mid-eighties dropping to the forties at night. Winter temperatures average highs in the forties and lows in the twenties. Each town and each county is a little bit different due to varying elevations and proximity to the mountains. Climate, small town atmosphere, sunshine and an overabundance of natural beauty draw millions of visitors to the region—each year, thousands find a way to stay. I am one of them.

No matter how many people eventually call Central Oregon home, it seems impossible that they won't remember to stop. Stop and marvel at the glory found in "the middle of nowhere."

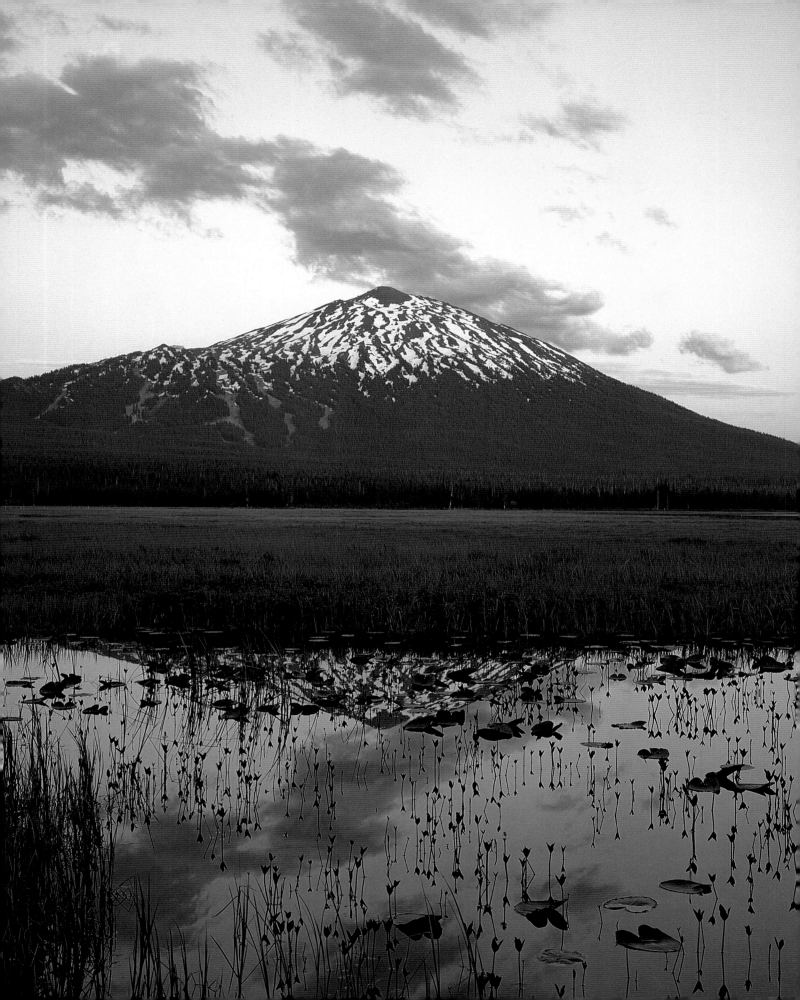

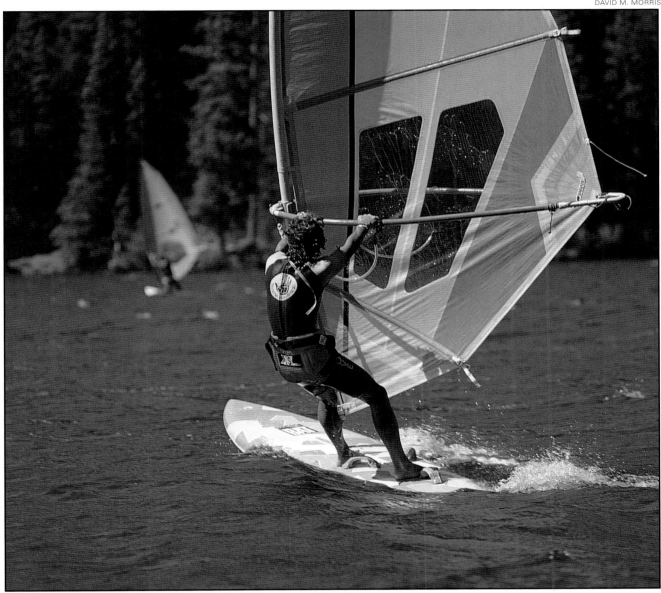

ABOVE: NAME ANY FORM OF RECREATION AND THERE'S EVERY LIKELIHOOD CENTRAL OREGON OFFERS IT.

FACING PAGE: THE STILL MAJESTY OF MOUNT BACHELOR REFLECTS IN A LILY POND AT SUNSET IN THE DESCHUTES NATIONAL FOREST.

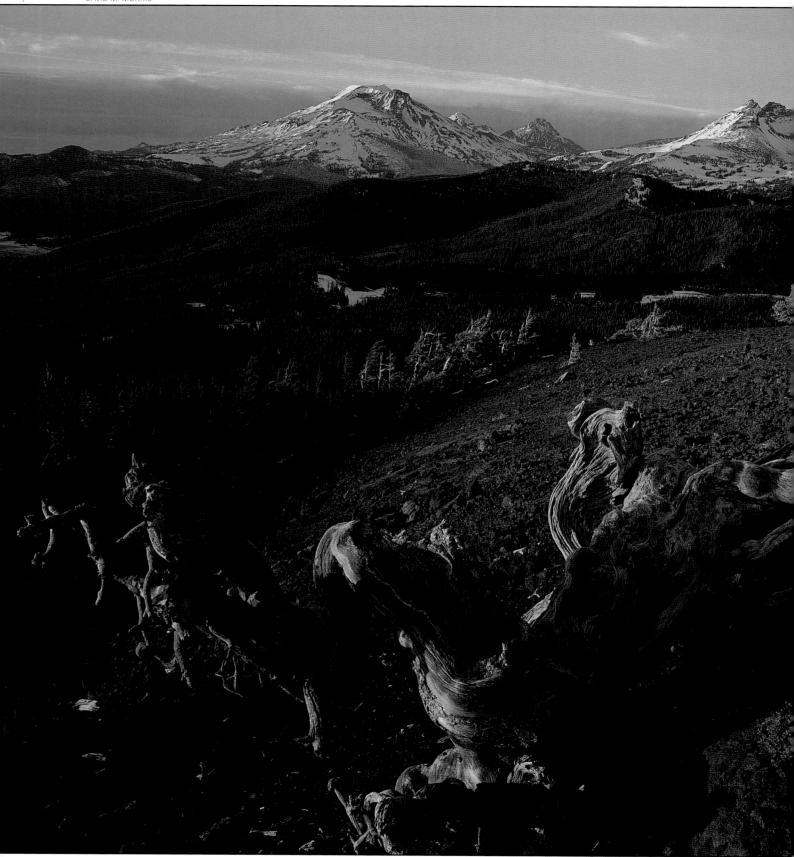

DAVID M. MORRIS

ABOVE: THE CINDER CONE ON MOUNT BACHELOR PROVIDES THIS VIEW OF THE THREE SISTERS AND BROKEN TOP MOUNTAINS.

FACING PAGE: GRASS TUSSOCKS AND RIFFLES IN ROCK CREEK ARE CAPTURED ON AN AUTUMN AFTERNOON IN THE SHEEP ROCK UNIT OF PICTURE GORGE, JOHN DAY FOSSIL BEDS NATIONAL MONUMENT.

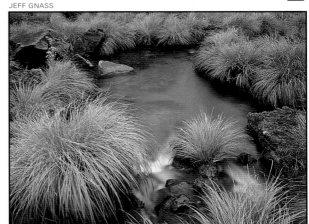

JEFF GNASS

So how was this wonderland created?

S tep out of the movie theater on Highway 20 in Bend, and you see one. Head for the High Desert Museum south of Bend, and you pass a couple more. Throw the skis on the car rack and drive to Mount Bachelor, and you'll soon be on one. Try to plant a garden, and you'll be stymied by the remnants of them. No matter where you turn in Central Oregon, there's some reminder of the volcanic activity that formed this region. The panorama of Central Oregon is a surround-stage of volcanism.

Two hundred million years ago the Pacific Ocean lapped against what is now Idaho. The makings of Oregon's mountain ranges, desert, and valleys were on the sea floor, and broad plains and sand spanned the old continental shelf. The first mountains to break above the ocean water creating an early coastal range were the Blue and Wallowa mountains, now in northeastern Oregon, and the Klamaths of northeastern California. Geologists believe that these mountains are fragments of old continents to the south. The mountains slid north to their present positions much as all land west of the San Andreas Fault slides north today.

For 150 million years the continent slowly migrated west, filling the oceanic coastal waters until about 50 million years ago, when descending slabs of ocean floor met the earth's searing interior creating one of the world's great spectacles. Magma eruptions exploded onto the once tranquil setting sending gigantic burrows upward and boiling molten lava and volcanic ash into the skies. Everything in its path was burned and buried—the kind of cataclysmic special effects of a Steven Spielberg movie. Volcanoes grew then sunk under the weight of tons of basalt and ash. The mountains went through a period of lifting and folding, and major fault lines rearranged them. This tremendous activity lasted for about 10 million years leaving the Western Cascades as its calling card.

As the volcanic Western Cascades calmed, cooled, eroded and became extinct, an outcropping of new volcanoes to the east began to form a parallel range. Earliest

activity began about 8 million years ago, but the late volcanic episode, from 4 million years ago to the present, is responsible for most of the huge, composite shield volcanoes that make up the High Cascades that border what is now Central Oregon. The volcanism here and in eastern Oregon not only bore volcanic cones and shields, but also blasted immense clouds of volcanic ash into the skies covering most of the state in dust. What the volcanoes erupted came under shaping effects of water, wind, and glaciers that left a landscape of mountains, cinder cones, spiraling lava plugs, rivers, lava flows and jutting volcanic ash canyons.

The Cascade Range, named after the roaring rapids at the Cascade Locks, has been "born again" on numerous occasions. Mount Hood erupted in 1853, '54, '59 and '65, and Mount Lassen blew in a series of spectacular eruptions in 1914. The devastating eruption of Mount St. Helens in the Washington portion of the Cascade Range in 1980 is the most recent reminder of the volatility of the scenery that looks so placid. The Cascade volcanoes, stretching from northern California to Canada, are part of the "Rim of Fire," the volcanic system that encircles the Pacific Ocean.

Geologists with the Deschutes National Forest say the average time between eruptions in Central Oregon is 500 years. The last major eruption was 1,300 years ago when the Big Obsidian Flow erupted in Newberry Crater. That makes the area overdue for volcanic activity. Until then, the wind vents, lava tubes, fumaroles and hot spots dotting the landscape give a sense of mystery about both the past and future.

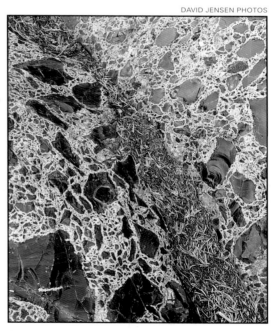

DAVID JENSEN PHOTOS

Not only is the High Cascades a majestic example of volcanism, but also it divides the state into two different climates. The creation of the High Cascades formed a rain barrier changing what was once a moist tropical climate in the eastern portion of what is now Oregon to the High Desert it is today. To the west is the rainy, lush landscape of the coast and Willamette Valley, and falling east off the wooded, snow-capped High Cascades is a sunny, more arid plateau pocked with a strange and sometimes blistered landscape of bluffs, rimrock, and buttes.

The High Cascades, with the Three Sisters, Mount Washington, Mount Jefferson, Three Fingered Jack, Broken Top and Mount Bachelor, is the visual signature of Central Oregon. Until you can name them, you can't *really* claim residence.

NATURE APPLIES A FILIGREE OF VEGETATION TO THIS OBSIDIAN CLIFF IN THE THREE SISTERS WILDERNESS.

Mount Jefferson and the Three Sisters (along with Mount Hood) are the youngest mountains in the High Cascades, created less than 1 million years ago. Although they sound like triplets, each of the Sisters peaks was a separate volcano. North Sister (10,085 feet) is the oldest of the mountains with about one third of its mass eaten away by glaciers. Today, three glaciers cover its slopes with part of Collier Glacier shared with Middle Sister.

Middle Sister (10,047 feet) is a smaller perfectly shaped cone and the site of the majority of the state's largest glacier, Collier, which covers its north flank. South Sister, the youngest and highest (10,358 feet), is the most identifiable of the peaks because of its crater cap. Peaks and cones clutter the area around the Sisters creating "the family" that includes Little Brother on the North Sister's flank, The Husband, west of Middle and South Sisters, and The Wife between South Sisters and Mount Bachelor.

FACING PAGE: RAVAGES OF TIME AND WEATHER SHAPED THESE TREE TRUNKS INTO WONDERFUL AND WEIRD SENTRIES ALONG A SLOPE IN THE THREE SISTERS WILDERNESS.

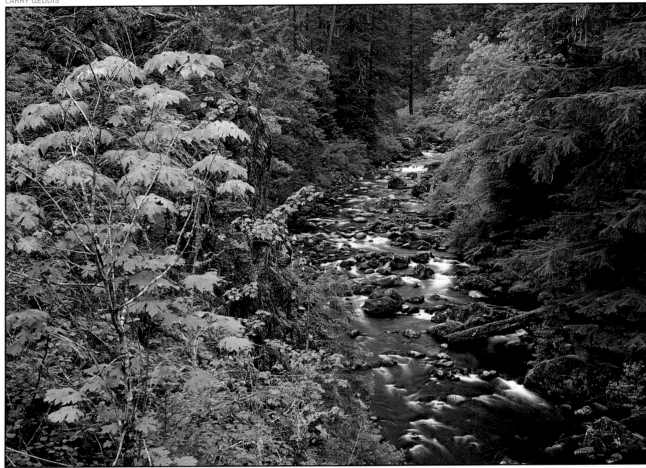

The Wild and Scenic McKenzie River tumbles through the Willamette National Forest.

One of the largest volcanoes in the Three Sisters region is Broken Top, a name now identified with the exclusive, gated golf-community west of Bend. The 9,175-foot mountain is a compilation of volcanic forces and glacier erosion. What was once its summit and entire southeastern flank no longer exists. In its place are layers of pumice, ash, basaltic rock and lava flows. Huge portions of the mountain seem scooped out, the result of glacial erosion. Hikers can follow trails along this barren flank and look down on the lush scene of Sparks Lake below. One of Broken Top's final volcanic displays was an eruption that sent rumbling avalanches sweeping down its northeast slope towards Tumalo Canyon.

Just east of Broken Top is Tumalo Highlands. This highly volcanic area erupted 600,000 to 200,000 years ago, prior to Broken Top's final eruption, leaving hundreds of feet of pyro-clastic deposits in the valley below. Where these torrents came to rest include the areas that are now the towns of Bend, Tumalo, and Sisters.

To the south of Century Drive, separate in its form and function, is Mount Bachelor. Home of the Mount Bachelor Ski Resort, this 9,065-foot symmetrical cone rises above the forested land 3,000 feet below. Its snowy slopes catch the alpenglow of winter sunrises and sunsets. Its peak is a maze of vents, depressions, and miniature craters. Basaltic lava flows cover much of its surface. There is minor erosion, indicating that this is a young volcano created after the last Ice Age.

Skiers can slide off Mount Bachelor's Summit Express, take off their skis and hike around one of the points to enjoy less crowded skiing and spectacular scenery. Each turn from the

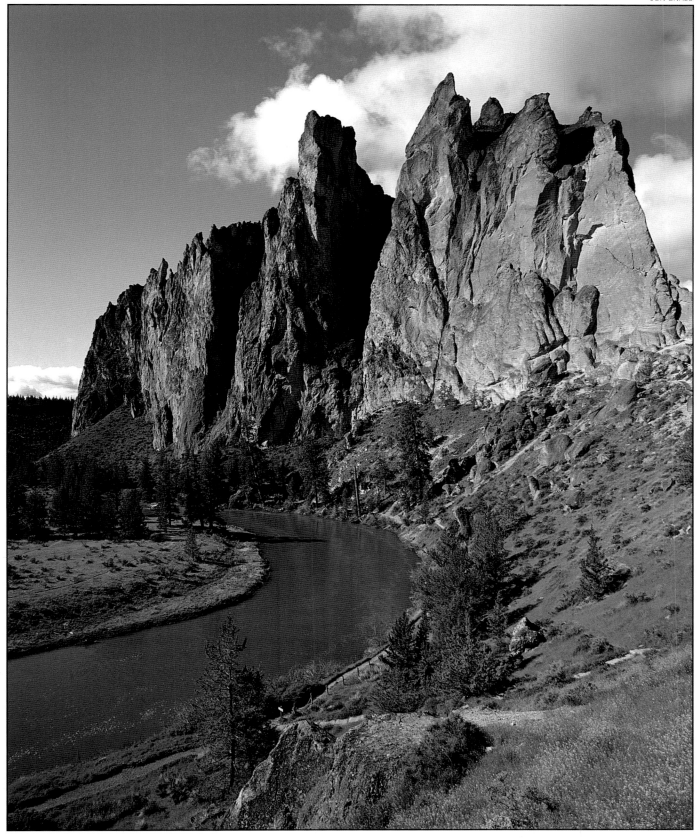

The Crooked River cuts a graceful arc on a course in Smith Rock State Park.

summit unfolds a different view: the massive formations of the Newberry National Volcanic Monument to the southeast, expansive reservoirs to the south, basalt flows spreading to Sparks Lake and the Western Cascades due west, and the varied peaks of Mount Jefferson, Mount Washington, Broken Top and the Three Sisters to the north. On clear days, the milky silhouettes of Mount Hood, Mount Adams and once in a while, Mount Rainier, poke up in the distance. In July, wild flowers blanket the slopes, in the winter skiers cover the face. Whatever season, the opportunity to be part of the landscape is addictive.

As accessible as Mount Bachelor is, Mount Jefferson is not. Standing aloof, it is the second highest peak in Oregon rising 10,495 feet to a jagged point. In 1806, Lewis and Clark named the peak after the country's third president and sponsor of their expedition. Covered in glacial ice, it shines year-round like a wintry beacon and is accessible only by foot or on horse-back. Geologists say that the original volcano was 12,000 feet high; after a series of eruptions, severe glacial erosion carved it into what thousands of photographers capture today.

The peaks of Mount Washington (7,794 feet) and Three Fingered Jack (7,841 feet) jut from gentle bases into steep summits. Mountains like these are oftentimes referred to as the Matterhorns of the Cascades. They are really lava plugs, a rather ugly name for such spectacular formations. This type of volcano forms in three stages beginning with a curved volcanic shield followed by a summit cone. The basaltic plug that pushes its way through the cone is the peaks' mast-like point formed by glacial erosion. Highly eroded peaks like these formed between the Ice Ages, while smooth cone-shaped mountains erupted after the last Ice Age.

Some of the most recent lava flows in the continental United States are seen from McKenzie Pass along Highway 242 west of Sisters. A blackened landscape spans nearly sixty miles, a dark contrast to the towering peaks of the Cascades and lush forest that surround it. The Dee Wright Observatory was built at the edge of Yapoah Crater flow. As little as 1500 years ago, basalt flowed from the nearby cinder cones.

Volcanism that thrust peaks toward the sky also helped create the region's spectacular—oft times hidden—lakes, waterfalls, and streams. Canyons of porous lava rock can absorb churning river waters turning them into tranquil pools. From the pools, water cascades and falls until man or nature again harnesses its power. The McKenzie-Santiam tour route runs from Highway 242 west out of Sisters, then north on Highway 126 through the Willamette National Forest back to Sisters. It is a perfect way to take in the flavor of the Cascades' geology. Proxy Falls, Koosah Falls, and Sahalie Falls thunder over lava cliffs or sink into old lava formations. A lava tube called Sawyers Ice Cave, views of Mount Washington, and access to a number of alpine lakes and trailheads dot the 130-mile route.

The dark green shroud of predominantly lodgepole and ponderosa pine and hemlock forests softens the harshness of these volcanoes. The woods turn to Douglas-fir as coastal moisture reaches them. These forests are home to eighty-four mammal species including deer, elk, antelope, pine marten, bobcat, wolverine, cougar, coyote and badger. There are still some black bears. What two-legged visitors see in abundance are rabbit, squirrel, and chipmunks. Two hundred forty-three bird species, including

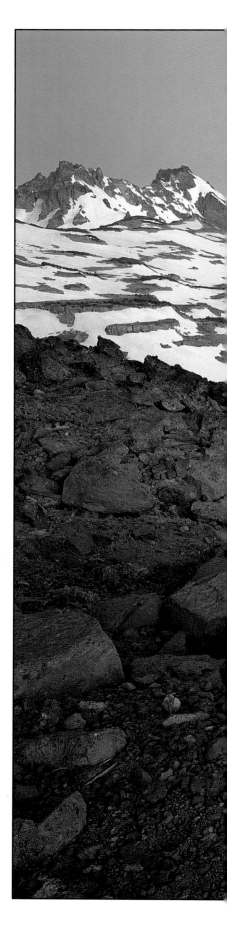

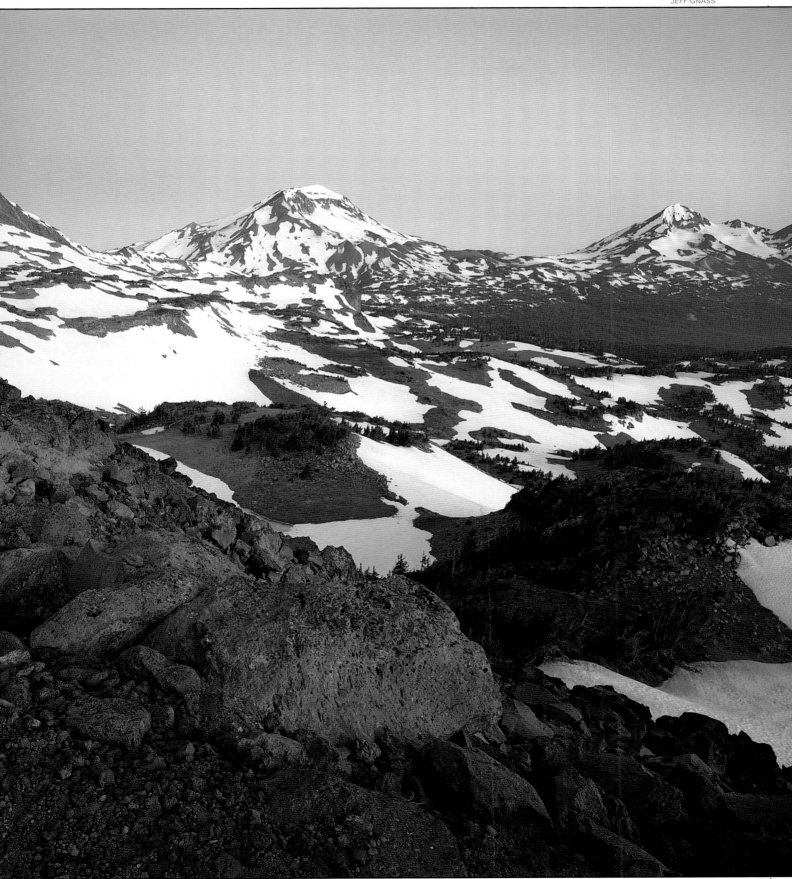

THE THREE SISTERS BLUSH IN THE TWILIGHT GLOW OF A JUNE MORNING AS SEEN FROM TAM McARTHUR RIM IN THE DESCHUTES NATIONAL FOREST.

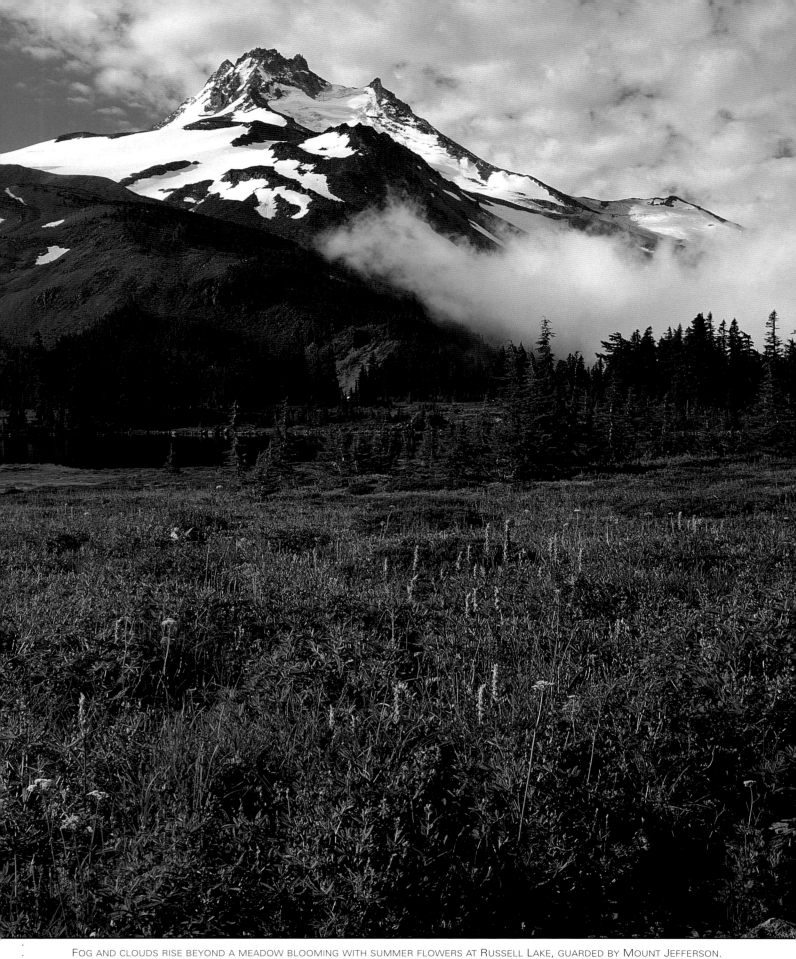

FOG AND CLOUDS RISE BEYOND A MEADOW BLOOMING WITH SUMMER FLOWERS AT RUSSELL LAKE, GUARDED BY MOUNT JEFFERSON.
LARRY GEDDIS

osprey, fish hawk, bald and golden eagles, red tail hawks and blue heron, fill the sky above the Deschutes National Forest. The once towering forest is mostly second growth, but still shelters all until it is once again cut for timber or charred by the great forest fires that plague the region. Western spruce budworm has taken its toll on over 150,000 acres of Central Oregon's wooded land, and beetles have infested the weed-like lodgepole pines that fill the desert fringe where ponderosas once stood. If you want to hug a tree, try a big old ponderosa. If you stick your nose into a crevasse in the bark, you can catch the distinct smell of vanilla.

Humans forever altered the forests of Central Oregon. Harvesting millions of acres and suppressing natural fires have created stands of trees with thick, unhealthy underbrush. Old ponderosa forests with little undergrowth can best be seen in historical photographs. Ponderosa bark is thick and naturally protects trees from fires, letting the flames clear the undergrowth. Today, acres of sickly lodgepole, devastated by beetle infestation and clogged by undergrowth, have replaced them. The subject of making healthy forests is a topic of hot political debate, and one of the greatest challenges facing the State of Oregon.

While the High Cascades frame the western side of the region, Newberry National Volcanic Monument blankets vistas to the south. This lumbering formation is the result of the single Newberry Volcano and the twenty-mile fault that runs along its northwest side to Lava Butte. It was designated a national monument in 1990. Newberry is not an extinct volcano; volcanic deposits occurred from 700,000 to 1,300 years ago making this young volcano a candidate for future eruption.

The Newberry Volcano, twenty-five miles wide, sits at an intersection of three fault zones. Its center is a five-mile-wide caldera called Newberry Crater. A caldera is a large crater formed when the crust of the structure is weakened and the top of the volcano collapses into the magma chamber under it during a great eruption. Filling two portions of this bowl are the beautiful Paulina and East lakes. Beneath the lakes is one of the hottest spots in the Northwest. In 1981, the U.S. Geological Survey drilled a 3,060-foot test well in the caldera and found temperatures of 510 degrees Fahrenheit. Geothermal exploration continues today. Alkaline hot springs are under each lake, and springs on the southeastern side of East Lake keep the ice melted through the winter months. A health spa once graced its shores; that burned in 1923 and again in 1941. Today only a rusted pipe bored into the lake's edge remains of the resort.

Vast barren spots of pumice deposits fill some of Newberry's landscape, providing snowmobile recreation areas in the winter and reverting to desolation in the summer.

Loops of trails circle the caldera and a twenty-one-mile path offers a trip filled with visual wonders. A short way from the parking lot is Paulina Falls. The usual cascading frenzy of water can freeze over in winter creating a challenging course to ice climbers, who scale its face. When the water tumbles over the eighty-foot falls, a contrast of older rock with its white silica coating is visible next to reddish rock, where a large section of the cliff crumbled in 1983. The trail goes through lodgepole and white hemlock forests then along the rim of Cinder Hill, where acres of volcanic cinders cover the land to the shores of East Lake. Volcanic cones and flows separated what was once one basin into two lakes.

On the south side of Paulina Lake is a 1.1-square-mile flow of black obsidian that erupted 1,300 years ago, making it the youngest dated lava flow in Oregon. Chunks of polished obsidian glass are part of a display next to the flow, where walkways wind through the volcanic rubble. One can only imagine how the slow-moving flow of high-silica rhyolite lava oozed down the slopes, clumping into jumbled masses of rock.

For an aerial view of this national treasure, you can hike or drive up the treacherous four-mile road of hairpin curves to the top of Paulina Peak (7,985 feet). The summit is the perfect vantage point to marvel at the schizophrenic creations of Mother Nature. On a clear day you

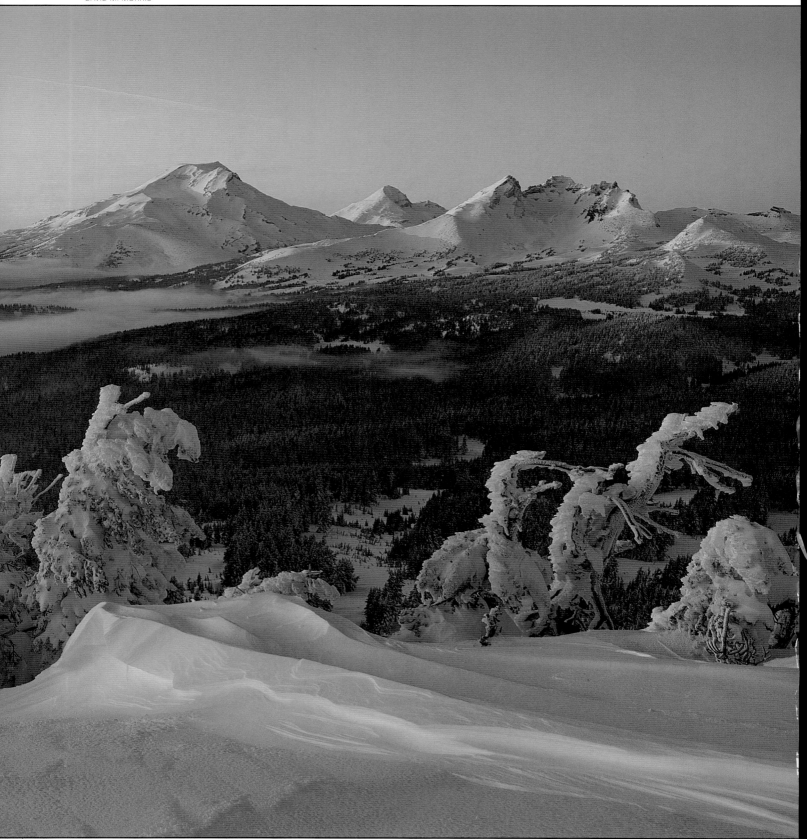

SOUTH AND MIDDLE SISTER AND BROKEN TOP MOUNTAINS REACH ELEVATIONS OF 10,358 FEET, 10,047 FEET, AND 9,173 FEET, RESPECTIVELY.

A STAND OF FIRS, CLAD IN NEW SNOW, GREETS A NOVEMBER MORNING IN THE WILLAMETTE NATIONAL FOREST.

can see the Cascade Range from Mount Shasta in California to Mount Adams in Washington. To the southeast on the High Desert lurks the strange formation of Fort Rock; it resembles a great whale in vanished Fort Rock Lake. Moonscape buttes like China Hat and East Butte crop up along the eastern horizon with the Ochoco Mountains to the northeast.

Smaller, younger cones (there are about 400 on all of the Newberry volcano), lava flows and vents follow the northwest rift zone extending from the caldera to the Deschutes River, and are part of the Monument. Along this rift, and accessed from Highway 97, are Lava Cast Forest, Lava River Caves, and the 5,020-foot-high Lava Butte. About ten miles south of Bend, motorists first catch sight of the rough, barren, black lava flows that erupted from Lava Butte about 7,000 years ago. One lava flow seems to stop at the edge of the highway. Lava from the cinder cone pushed its way to the Deschutes River, filling the canyon with more than 100 feet of lava. The resulting panorama from the other side of the river is a chilling contrast of tumbling blue water, black lava and buff-colored bluffs dashed with aspen and willow trees usually set against a vivid blue sky.

A visitor's center and interpretive facility is at the base of Lava Butte, and tourists walk or take buses to the top of the cone during summer months. They can also use trails through the lava beds. By the way, once a cinder cone erupts, it is one dead volcano.

Newberry's lava flows created other strange spectacles. Lava Cast Forest is just that—molds of pine trees enveloped by hot lava. These 7,000-year-old remnants litter a five-square-mile area off Highway 97. Lava River Cave, a partially collapsed lava tube, runs 5,000 feet and is the state's longest lava tube. Great halls as high as fifty-eight feet and openings as small as five and a half feet run along this volcanic corridor.

Eruptions of Mount Mazama that created Crater Lake (eighty-five miles southwest of Bend) and eruptions from Newberry Volcano blanketed much of Central Oregon with pumice and ash. At Lava Butte, twenty-two inches of Mazama ash fell and covered the land 7,700 years ago. Due east of Bend on Highway 20 a patchwork mosaic of larger volcanoes and smaller buttes, like the brown obsidians of Glass Butte, dots the landscape. Basalt cliff formations of buff-toned pumice protrude along the horizon. Newcomers may find the area inhospitable but, of course, it is alive with miniature plants and a world of wildlife including small mammals, birds, lizards, and snakes. These plants and animals are in a constant ecological battle with people and the cattle and sheep that graze the plains.

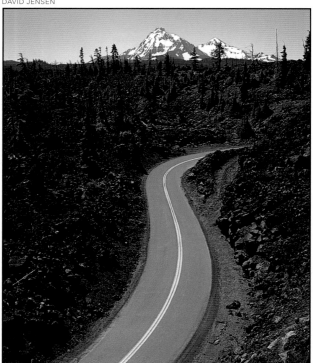

DAVID JENSEN

THE MCKENZIE PASS HIGHWAY IS A WELL-TRAVELED ROUTE THROUGH THE MCKENZIE LAVA BEDS AND THIS VIEW OF NORTH AND MIDDLE SISTER MOUNTAINS.

Another kind of marvel can be found in the most majestic cliffs of Central Oregon. Smith Rock State Park, northeast of Redmond, sits on the edge of the Lava Plains. Over millions of years, the Crooked River slowly worked its way through a pile-up of volcanic ash, rhyolitic lava, and mud flows cutting a canyon of vertical pillars and sheer red cliffs. Wind and water erosion added to the artistry that has created one of the finest rock climbing venues in the world. Strange formations, like Monkey Face, stand as sentinels against the blue sky.

Other rock formations, like the Ship at the Cove Palisades State Park near Madras, are further examples of rivers cutting through nature's volcanic refuse. Here layers of glassy ignimbrites, basalts, and sediments were exposed after the ancient Deschutes River did its work.

To get the full picture of millions of years of volcanic artistry, one should follow Highway 26 past Prineville through Crook County over the Ochoco Mountains and into the John Day Fossil Beds National Monument. The 14,000-acre monument is divided into three units: Clarno, Painted Hills, and Sheep Rock. Part of the National Park System, the monument offers a visitor center at the old James Cant ranch house in the Sheep Rock Unit on Highway 19.

Seemingly deprived of plant life, the geology of the area nonetheless is mesmerizing. Bands of color undulate on the horizon, documenting millions of years of history. This barren splay of evolution is made possible by relentless erosion. What remains is a panorama so soft and subtle in its coloration that it is hard to imagine the violence of bursting fissures and one-hundred-mile-an-hour pyroclastic flows and glowing avalanches that helped create the landscape. In each layer is preserved some of the world's richest fossil beds, each one a partial record of 45 million years of the continent's creation.

The first non-Indians to discover the area were men on military expeditions. In the early 1860s, scientists began research of the fossil beds. Studies continue today. On March 16,

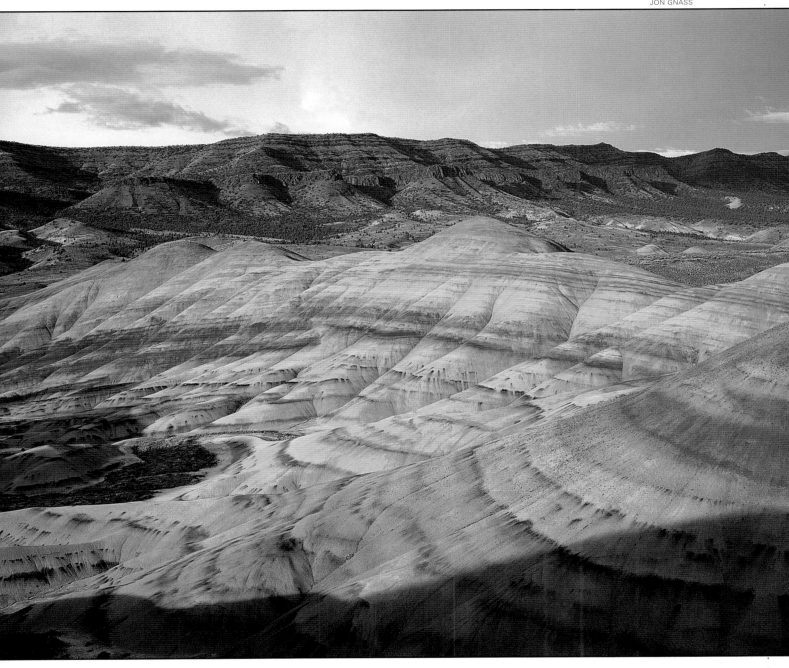

Sunset on a June day brings a palette of warm hues to life on the Painted Hills in the John Day Fossil Beds National Monument.

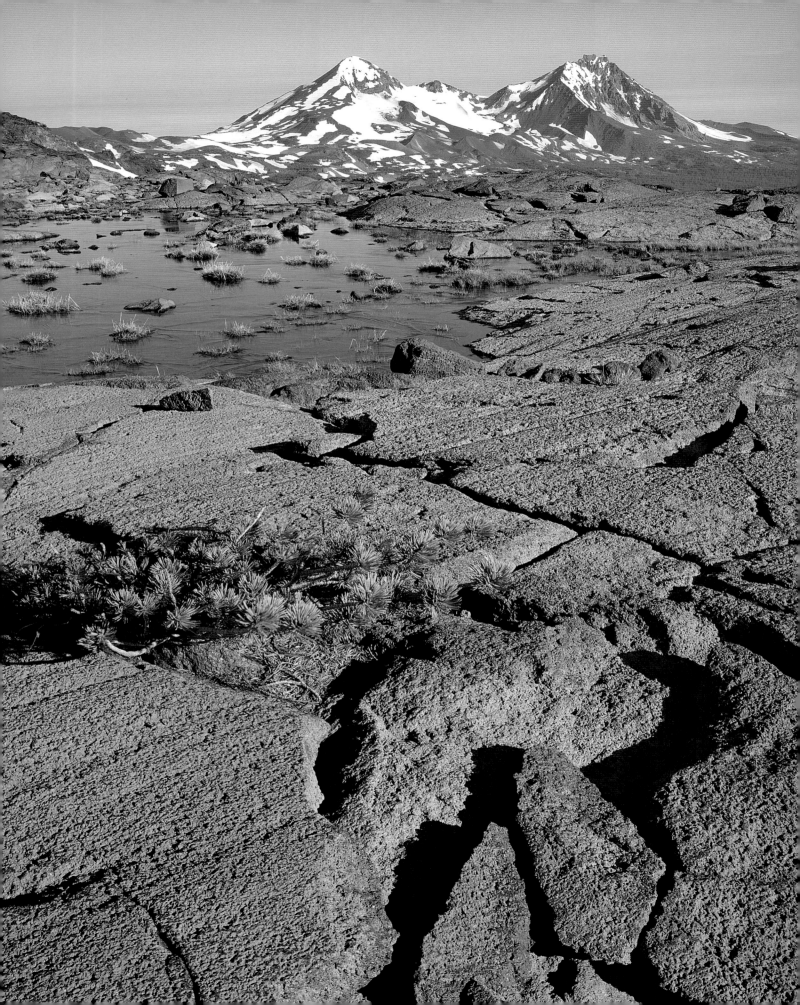

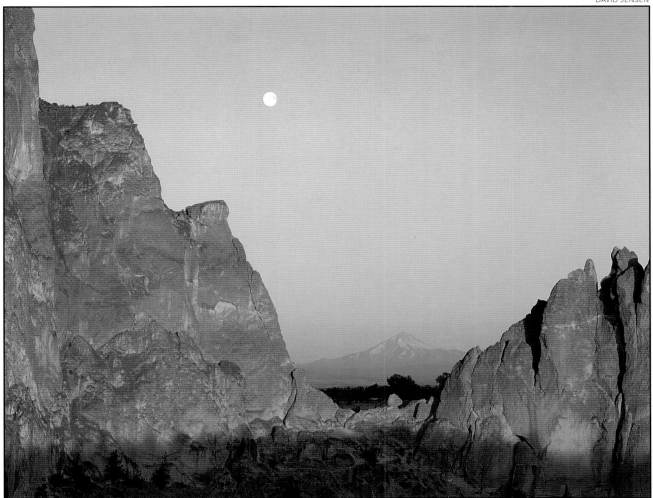

ABOVE: ASTERISK PASS IN SMITH ROCK STATE PARK OFFERS THIS VIEW OF MOUNT JEFFERSON AT SUNRISE.

FACING PAGE: WHITEBARK PINE WELDS ITSELF TO BASALT BY A POOL OF SNOWMELT WITH MIDDLE AND NORTH SISTER MOUNTAINS IN THE BACKGROUND. JEFF GNASS

1995, newspapers reported that a fossilized banana, found twelve years before in the Clarno Formation, finally had been determined to be 44 million years old. Conversations at lunch counters and coffee shops in Central Oregon picked up on the report that one newspaper headlined: "Talk about being overripe: Ponder prehistoric banana."

Cathedral Rock on Highway 19 is part of a huge, ancient landslide that diverted the flow of the John Day River. With its upright palisades and rainbow of colors, it is a stunning example of the John Day Formation. Blue Basin, also off Highway 19, is a huge cup of volcanic ash turned into claystone by millions of years of alteration and erosion. Minerals have colored it a pastel blue wash. Mount Mazama (Crater Lake) ash, pinnacles, and badlands topography are all part of the basin.

The most accessible unit to Bend off Highway 26 is the surreal Painted Hills. Mounds of banded red, buff, and black clays and shales suddenly undulate along the horizon. Wooden walkways wind through the hills to protect the delicate landscape.

Every curve of the road in the John Day Fossil Beds National Monument offers a new vista, a new treasure, a new clue to the mystery of the earth's existence.

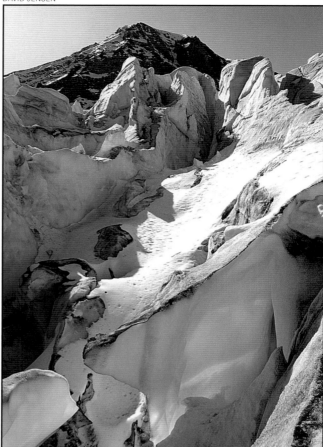

DAVID JENSEN

RIGHT: HAYDEN GLACIER IN THE THREE SISTERS WILDERNESS.

BELOW: PAULINA LAKE IS SEEN FROM PAULINA PEAK IN NEWBERRY CRATER NATIONAL VOLCANIC MONUMENT. THREE SISTERS MOUNTAINS ARE ON THE HORIZON.

FACING PAGE: THE DESCHUTES RIVER PERFECTLY MIRRORS A CLOUDY, OCTOBER SKY. DAVID M. MORRIS

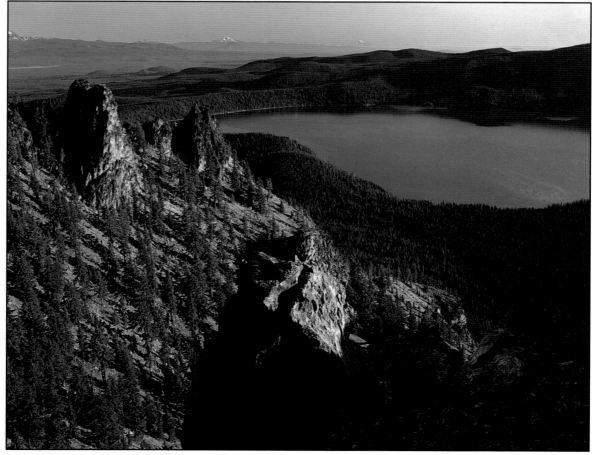

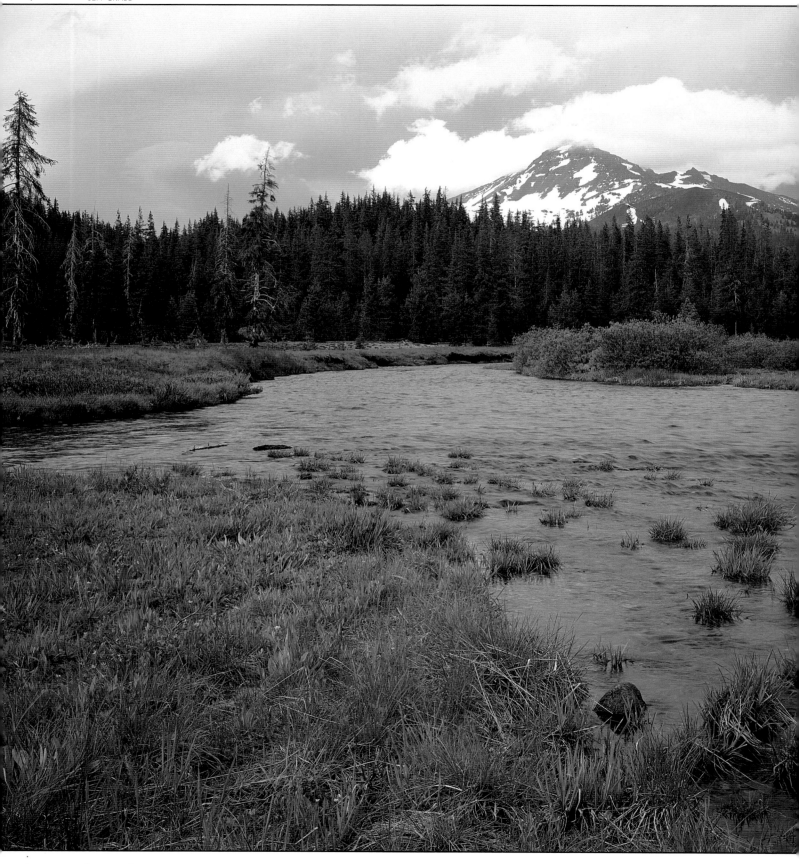

ABOVE: STORM CLOUDS GATHER ON A SPRING AFTERNOON OVER BROKEN TOP MOUNTAIN AND FALL CREEK ALONG THE CASCADE LAKES HIGHWAY SCENIC BYWAY IN THE DESCHUTES NATIONAL FOREST.

FACING PAGE: BACKCOUNTRY SKIERS ON HAYDEN GLACIER IN THE THREE SISTERS WILDERNESS.

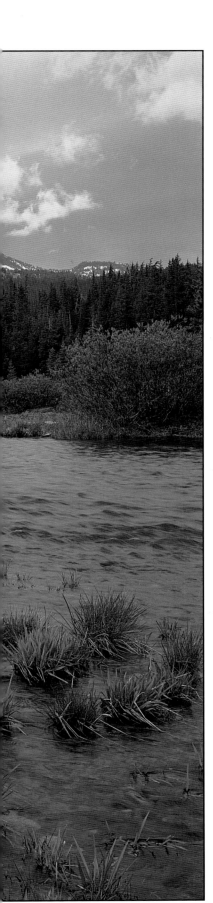

FRED PFLUGHOFT

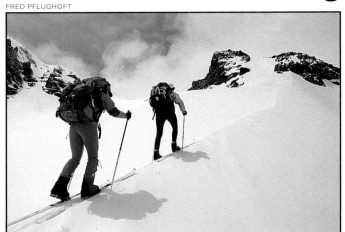

And then there were people

The history of Central Oregon is a legacy of endurance. The region's pedigree is as much the process of arriving as of settling. For no matter where the first inhabitants came from, barriers to their arrival were tremendous. Here is a pocket of land with lava-strewn, glacier-covered mountains on one side and an arid, treacherous desert on the other.

But they came. In 1938, Dr. L.S. Cressman of the University of Oregon supervised an anthropological dig around the volcanic tuff of Fort Rock Basin southeast of Bend. What he and his students found altered the known history of Central Oregon. Buried in a cave of pumice castoffs were tule bark sandals still caked with mud from the shores of a pre-historic lake. Further excavation in the cave unearthed hunting tools.

How these people came to the Fort Rock Basin is anthropological speculation. Lakes that once filled the region eventually dried up. Following the final Ice Age, the area was lush and vegetation sustained deer, bison, and antelope. Anthropologists maintain that today's Native Americans are descendants of hunters and gatherers who migrated from Asia during the last Ice Age.

As the region became semi-arid they moved on, in time replaced by other Indian bands. Before white explorers set their sights on Central Oregon, a number of Tribes traveled through the area from the Columbia River then along the mountains in a seasonal progression, hunting, picking berries and digging roots. The first trails many explorers and trappers followed north to south were Indian migration routes.

The northern Paiute lived in the harsh land and their life reflected the geography. Their homes were in caves or domed wickiup shelters made from poles and grass matting. There were no herds of roaming bison like those sustaining Great Plains Indians, no rivers filled with salmon like those found by the mid-Columbia Tribes. Food was a constant challenge, and the people subsisted on berries, roots, antelope and rabbit meat in good times and on rodents and snakes in lean days. The Tribes'

social structure revolved around the nuclear family, and when they gathered in groups for the winter, it was in small bands of a dozen or so people.

The river Tribes had an easier, more bountiful life that revolved around the salmon-filled rivers. They made their homes in villages along the "great river," the Columbia, and at the mouths of the Deschutes and John Day rivers and its tributaries. The Wasco Indians primarily fished and traded with other Indian Tribes and bands throughout the region that linked the Northwest Coast, Plateau, Great Basin and beyond. Unlike the Walla Walla (one of many Tribes later called the Warm Springs), they had permanent villages along the Columbia. Theirs was an active and very commercial society of trading and socializing.

The Walla Walla bands traveled a vast territory in the spring, summer, and fall hunting, fishing, and collecting roots and berries. Their spiritual lives were inseparable from their daily routines, and when they moved their villages to more sheltered areas for winter, life revolved around ceremony and religion.

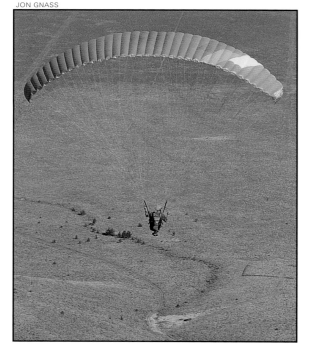

JON GNASS

PARAGLIDER FLOATS OFF PINE MOUNTAIN.

They fished the rivers with the Wasco and crossed paths elsewhere with other bands. Any contact with the Paiutes to the south was usually confrontational. Part of what is now Warm Springs Reservation was the common ancestral food grounds of the three groups.

The Wasco and Walla Walla Tribes and bands took the arrival of white explorers, trappers, and traders in stride, all part of open trade Northwest-style. Journals of early white explorers reflect the initial trust and friendliness of the Columbia River Indians.

While whites needed the Indians, the Tribes had no real need for trappers and explorers. Indians traded basic necessities like meat, fish, horses, and information for blankets and trinkets. Yet, it didn't take long for them to realize the implications of this new civilization.

The first explorers came to the Pacific Northwest in search of a much grander vision. Trapping, local trade, and settling would come later. They hungered for the great waterway that would open up trade from Asia—the Northwest Passage. Beginning in 1541, and continuing for over 200 years, the Spanish, English, French Canadians and Americans searched. It wasn't until 1792 that Englishman George Vancouver set the myth of the Northwest Passage to rest.

What these men found as they explored inlets and eventually went up the Columbia River was an immense land of incredible beauty. Vancouver named the Cascade Mountains "Snowy Range."

Instead of the coveted passage, they found the Columbia River filled with salmon and trout, land brimming with beaver and otter, and forests so tall and dense that they cut out sun as completely as a total eclipse. The huge, towering trees were more obstacle than the great economic bounty they would one day produce.

The first plunder of the land was by the French Canadians, who trapped and hunted the sea otter and beaver of the Northwest to near extinction. Two entities, the North West Company and Hudson's Bay Company, virtually ruled what was called the Oregon Country

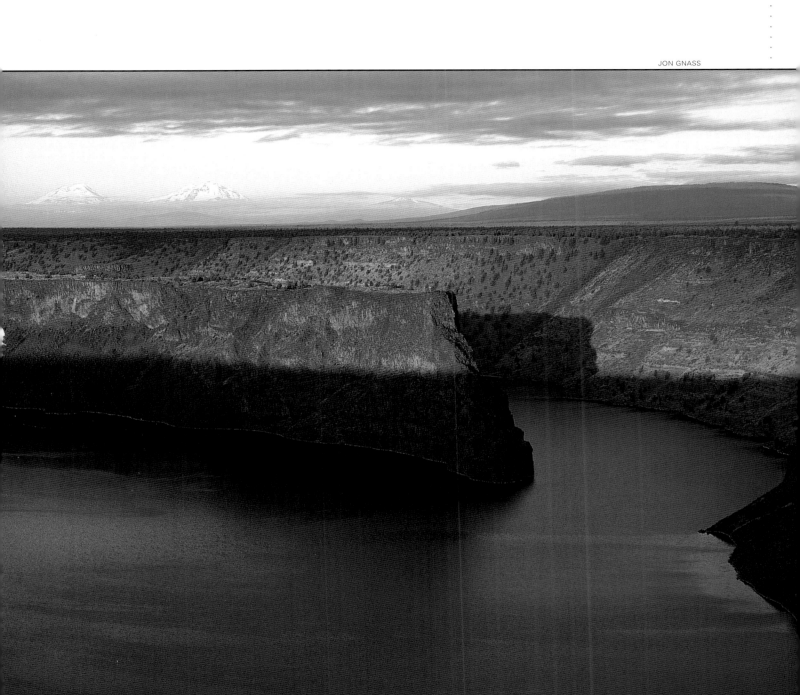

A MAY SUNRISE REVEALS LAKE BILLY CHINOOK IN THE COVE PALISADES STATE PARK. IN THE DISTANCE, THE THREE SISTERS MOUNTAINS.

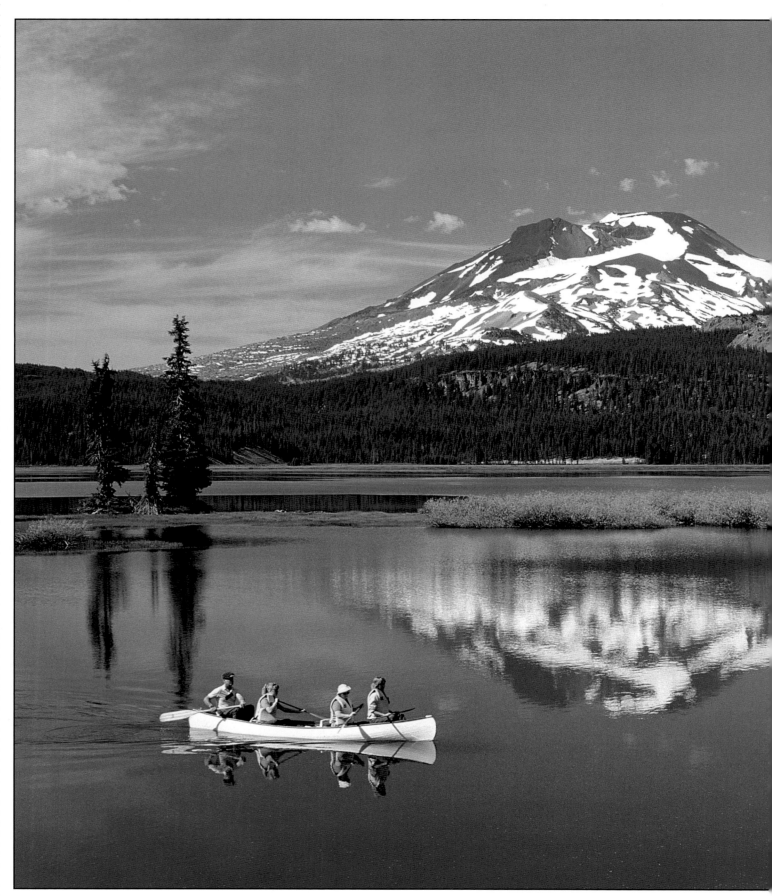

Sparks Lake provides fishing and boating fun and a reflection of South Sister Mountain.

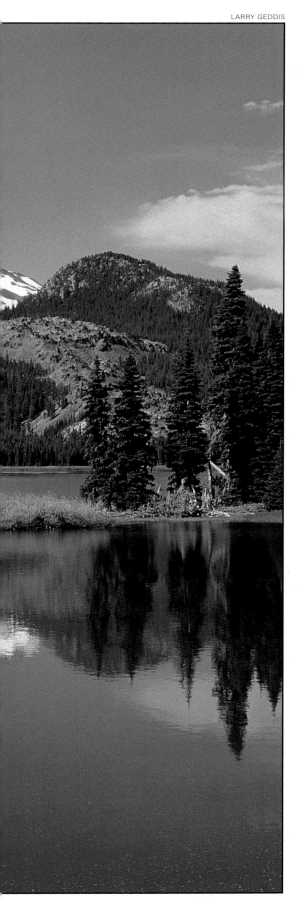

from the mid-1700s into the 1800s. It was an extensive land mass, including all of what later became the states of Washington, Oregon and Idaho, and portions of Montana and Wyoming as well as the Canadian provinces of British Columbia and Alberta. The two commercial powers merged in 1821 to end their feud and a twenty-one-year trading monopoly covering the Oregon Country was granted to the new company by the English crown.

In 1825, Peter Skene Ogden, a Hudson's Bay Company trapper, was sent to trap out the entire watershed region of the Snake River east of the Cascades. The point was to make trapping undesirable to American trappers and traders, keeping them east of the Rockies.

In 1804, Meriwether Lewis and William Clark set out from St. Louis on their immortal expedition. The party of thirty-three entered the Oregon Country in 1805. Theirs was one of the most successful expeditions of its kind. As they neared inhospitable expanses of eastern and Central Oregon, Lewis and Clark determined much of the area useless for farming and ignored the region. Instead, they traveled west along the Columbia River, and in the spring of 1806, crossed the Cascades, naming Mount Jefferson and the Cascade Range the "Western Mountains."

It was trapper Ogden, surveying the southern tributary of the great Columbia River in search of remaining beaver, who first documented an exploration of Central Oregon. In 1825, he worked his way from Fort Nez Perce in southeastern Washington south into the Dry Creek area near the present town of Warm Springs. On a corresponding journey was Finan McDonald, who crossed the Cascades between Mount Jefferson and Mount Hood. McDonald and Thomas McKay explored the Upper Deschutes to the site of the town of Sunriver, then went north to Ogden's camp at Dry Creek on what is now the reservation.

On a bitter cold December day in 1825, the two chilled and weary groups crossed the Deschutes River downstream from the present bridge at Warm Springs. On the basis of McKay and McDonald's report, Ogden turned the expedition southeast to Ochoco Creek and the Crooked River. The party continued over Grizzly Mountain near what is now Prineville, then followed the Crooked River east. Bitter weather continued and they struggled on, surveying, trapping, and nearly starving. On January 11, 1826, the expedition moved out of Deschutes Country. Ogden made good on his vow to return in 1826. With a party of thirty-five trappers and Indians he returned to Central Oregon, and pushed farther south along the Deschutes into what became Lake County. It was on this expedition that he discovered East and Paulina lakes set in the caldera of Newberry Crater.

Expeditions continued sporadically through the 1830s. In December 1834, Boston businessman Nathaniel Wyeth arrived

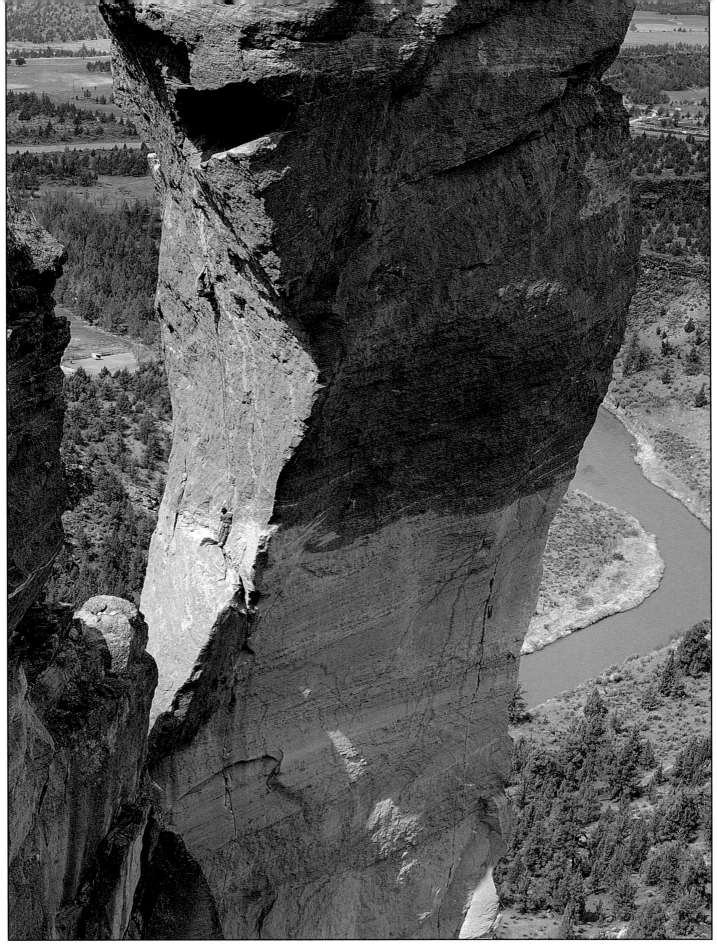

CLIMBERS RISE TO THE CHALLENGE OF *MONKEY FACE* ROUTE ON A CLIFF IN SMITH ROCK STATE PARK. DAVID M. JENSEN

at a trapper's camp south of Bend near Benham Falls. He spent two months in the deep chill of winter working his way north to the Columbia River. Eight years later, John C. Frémont, working for the Topographical Engineers of the U.S. Army, reached The Dalles then started up the Deschutes through Warm Springs, past Benham Falls and then south. With him were Kit Carson, and Billy Chinook, a Warm Springs Indian, memorialized by the massive reservoir, Lake Billy Chinook, north of Bend on the Deschutes River.

Those outsiders who ventured into the Oregon Country before 1846 were unsure of exactly what government they would be under. That year, the great Oregon Country was divided between the British and United States at the forty-ninth parallel, now the Canadian border. In 1849, present-day Oregon was designated a territory of the United States.

Then it happened. Propelled by a spirit of adventure, hope, and fear, thousands of Americans packed their belongings on covered wagons, and from 1841 to 1850, began the great migrations West. Oregon's fertile valleys, mild climate, free land and comparative freedom from malaria seemed worth the gamble. The Oregon Trail of 1843 bypassed Central Oregon as it crossed the Snake River Plain over the Blue Mountains and down the Columbia River, following a route blazed by Hudson's Bay Company trappers. These pioneers made it possible—no, probable—that Central Oregon too would be settled. For these were individuals ready to stake out the claim of Oregon Country not only for themselves, but also for America. They would plant themselves as firmly as any native tree in the name of religious freedom, capitalism, and a democratic government. They had beaten the British once, and it was time to do it again. Not with regiments of militia, but with families of stoic Americans sometimes giddy with the anticipation of this new frontier.

In 1993, when the Northwest celebrated the 150th anniversary of the Oregon Trail, residents were humbled by the sacrifice of these settlers. Historical exhibits laid open the determination, pain, and suffering of men, women, and children beaten down by the elements, sometimes lost, ravaged by disease. While popular culture has portrayed Indian raids as a major threat of the pioneers, in fact, it was stampeding stock, broken wagons, careless use of firearms and skirmishes between frantic and frustrated settlers that killed and injured those not taken by disease.

The exhibit, *Oregon Trail Wandering Wagons, Meek's Lost Emigrants of 1845* at the High Desert Museum outside of Bend, attracted 238,325 visitors from May of 1993 to June of 1994. Excerpts from diaries drew visitors back in time. Throngs of people followed the trail through the museum exhibit. A silence seemed to overcome all as they read firsthand, unemotional accounts of daily life on the Oregon Trail.

It was the same sort of feeling that Bob Boyd, curator of the exhibit, experienced when doing research on the Meek's Trail:

"In retracing their journey in mid-summer, 150 years after their passing, we found it to be an arid and empty landscape little touched by progress since 1845. Reading their diary entries, finding their campsites, weathered stumps where they cleared a path for their wagons and the ruts of their wagon wheels on the hillsides, emphasized what a truly grim ordeal their journey must have been."

In August of 1845, 200 families signed on with trapper Stephen Meek, who sold them on a shortcut across the Oregon desert. Long on bravado and short on specifics, Meek led the families on a trail used by trappers on horseback, not families with oxen and wagons. The party, detouring from the Oregon Trail at Vale, found the arid, barren desert with the endless basins, alkaline water, and rocky plains to be a heavy burden for even the most stoic pioneer.

For six weeks, about 1,000 emigrants plodded through deep, choking dust on the arduous trek. At one point the men on the train, so outraged over the route and what they saw as certain death, discussed killing Meek. Instead, the emigrants split into two groups. Solomon

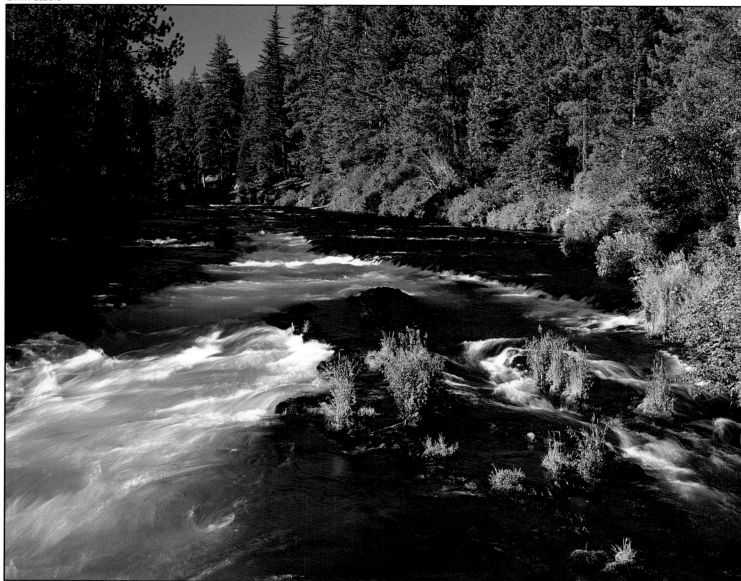

THE WILD AND SCENIC METOLIUS RIVER RUSHES THROUGH THE DESCHUTES NATIONAL FOREST.

Tetherow led one group, which some believe included Meek and his wife Elizabeth, and headed west toward the Bear Creek Buttes. During the trip, a nugget of gold was discovered by children and put into a blue bucket. There are dozens of versions to this story, but the nugget's vein was never found. The breakoff group was dubbed the Blue Bucket Party. The other group followed the Crooked River past the present site of Prineville, eventually finding their way to Sagebrush Spring southeast of where the town of Gateway now stands. There they rendezvoused with the Tetherow train. While the treacherous desert crossing had been accomplished, the price had been very high. Entire families were sick and dying. And the trip was far from over. Dangerous river crossings and miles of inhospitable land still lay ahead.

The Meek wagon train made its way northwest to the mission at The Dalles. A sandy, two-mile portion of that trail east of Deschutes Junction, between Bend and Redmond, is preserved as "Huntington Road, Central Oregon's Piece of the Oregon Trail." Contemporary history buffs—dressed in comfortable hiking boots, well fed, and rested—can barely imag-

ine the hardship of the pioneers, weary, sick, and hungry, as they zigzagged along the trail following the path of least resistance.

By the time they straggled into The Dalles, at least twenty-four had died. More would die before they reached Oregon City.

October 7

This morning nothing to eat. got to the mishion at dark, 17, got in a house with my family. got something to eat. this was the first day we had done without something to eat But some of the company had been without bread fore 15 days, and had to live on pore beef without anything else. I will just say, pen and tong will both fall short when they gow to tell of the suffering the company went through....

Thare my wife and chils died, and I staid till the 3 of November, when I left fore Oregon City in a large canoe with four indiens for which I give sixty dollars. ...I did not expect to git to the city with my fore sick children and my oldes girl that was sick I was lookng all the time for hir to die.

—excerpts from the diary of Samuel Parker

Meek's train is thought to have been the largest of three groups to cross the interior of Oregon between 1845 and 1854. The first two found themselves fragmented, lost, near starvation and finally rescued.

In 1852, residents of the Upper Willamette Valley began promoting the idea of an emigrant trail through the Cascades of Central Oregon. There had been unsuccessful attempts at surveying a pass, but by 1852 a group of men persuaded the Oregon Territorial Legislature to grant a private contract for construction of the new road—the Free Emigrant Trail. The road-viewing party planned, surveyed, and eventually cut a right-of-way of sorts from the Upper Willamette Valley to the Deschutes River.

It was with the understanding that this road would be complete that Elijah Elliott led a large wagon train on the second ill-fated trek west across the Central Oregon desert and over the Cascade Range. Over 1,000 people, a couple of hundred wagons, and livestock left Fort Boise in 1853. Elliott was sure they could save time by crossing the High Desert, but was unfa-

FRED PFLUGHOFT

ADVENTURE COMES IN ALL SIZES IN THE THREE SISTERS WILDERNESS.

miliar with the terrain and abandoned the Meek Trail, heading instead toward Steen's Mountain at Harney Lake. Elliott and others, including some who had been on the original road-viewing party, argued about various routes, divided and sometimes regrouped. The settlers struggled through the Harney Valley toward the Deschutes River and eventually straggled into what is now the Bend area.

Once on the Deschutes, they worked hard to find where the road-viewers had come upon the river. During the chill of late October, they headed over a road that was poorly built through the pines and rugged mountains. Fallen trees clogged the hastily cleared roadway. Some of the emigrants became stranded south of Diamond Peak; scouts sent earlier in search of help had not arrived. The group was frightened and starving, with little hope of survival. Then, school teacher Martin Blanding headed out to find help like a hero in a dime novel. Residents of a small community found him and rescued the stranded settlers. Fortified, they traveled on to establish a road over what is now Willamette Pass.

In 1854, William M. Macy, one of the early road viewers for the Free Emigrant Trail, led a fairly successful train of about twenty wagons westward taking the cutoff from the Oregon Trail and heading across the High Desert and Cascades; others followed that year. Just when the route was finally conquered, promoters of the road turned to other concerns including the Indian War of 1855.

As daunting as crossing the Cascade Range seems, this way provided the routes for most settlers who eventually came to Central Oregon. Already seasoned by the trek west across the Oregon Trail, the new emigrants' next move was from the Willamette Valley east in search of less crowded land, grasslands, and sometimes gold. Some of the original men on the Elliott train returned to the High Desert in search of the gold supposedly found by the Blue Bucket Party.

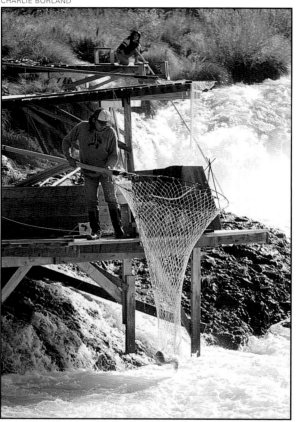

CHARLIE BORLAND

INDIANS NET STEELHEAD ON THE DESCHUTES RIVER.

During the 1850s and 1860s, several military expeditions surveyed Central Oregon with various orders to view roads for wagon trains and to escort those trains. In 1859, Captain H.D. Wallen left from The Dalles and headed across the High Desert. Major Enoch Steen followed soon after; the spectacular Steen's Pillar (often misspelled Stein's) on Mill Creek now bears his name. These military expeditions sometimes included Warm Springs Indians serving as scouts.

The discovery of gold in the John Day Basin in 1860 brought a new and often unsavory breed to eastern Oregon. Miners staked claims and ranchers herded in livestock and tamed the ranges of Central Oregon, finally overgrazing until they destroyed much of the natural grasses of the once fertile region.

If the hardships and sacrifices of the white settlers seem overwhelming, they pale when compared to the injustices brought upon the Indians. As settlers laid claim to prime tracts of Oregon land, the Indians, whose culture and use of the land had no place for fences or plots or townships, were being squeezed. In 1855, Joel Palmer, superintendent of Indian Affairs for the Oregon Territory, got orders to clear the Indians from the "settlement" lands. One of the treaties Palmer drew up eventually created the Warm Springs Reservation. On June 25, 1855, eighty-nine tribal representatives from the Tygh Valley, Columbia River, and east of the Deschutes River were brought together. They primarily represented various bands and Tribes of the Tenino, Tygh, Dog Rivers and Wasco Indians. Three days later, they had given up 10 million acres of land and were left with rights to about one twentieth of their original lands. They also retained rights to fish, hunt, and gather food in their traditional ways on their ancestral land. It was a peaceful treaty, and one whereby the Indians hoped to protect their culture and live in peace. That was hardly the case.

They had traded with, been guides for, and attempted to co-exist with, the newcomers. Even after being confined to the reservation, members of the Warm Springs Reservation Tribes joined the Army's fights against hostile Paiute Indians who terrorized settlers and raided the Warm Springs Reservation from 1857 to 1861.

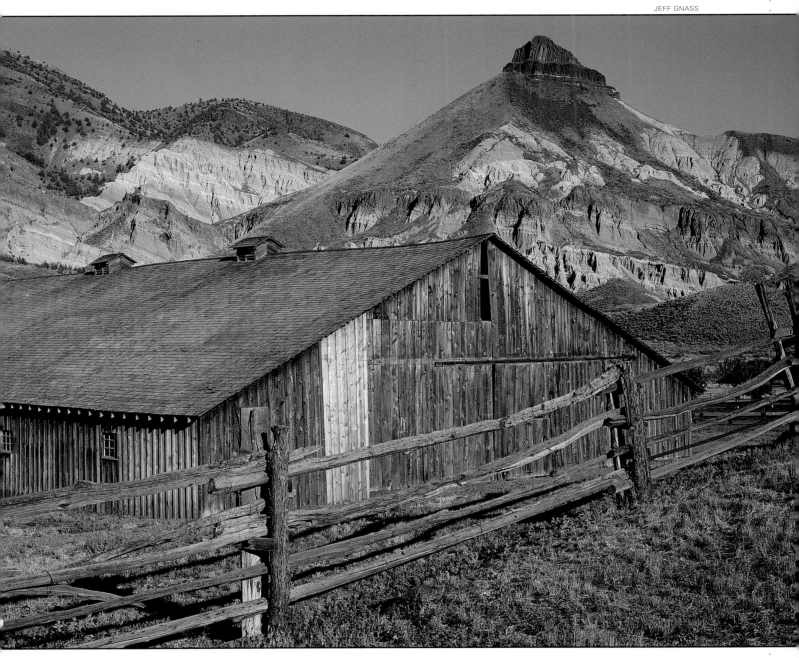

COLORS OF THE BARN ROOF AND WALLS AND THE FENCE AT CANT RANCH BLEND WELL WITH THE LANDSCAPE AT THE SHEEP ROCK UNIT OF THE JOHN DAY FOSSIL BEDS NATIONAL MONUMENT.

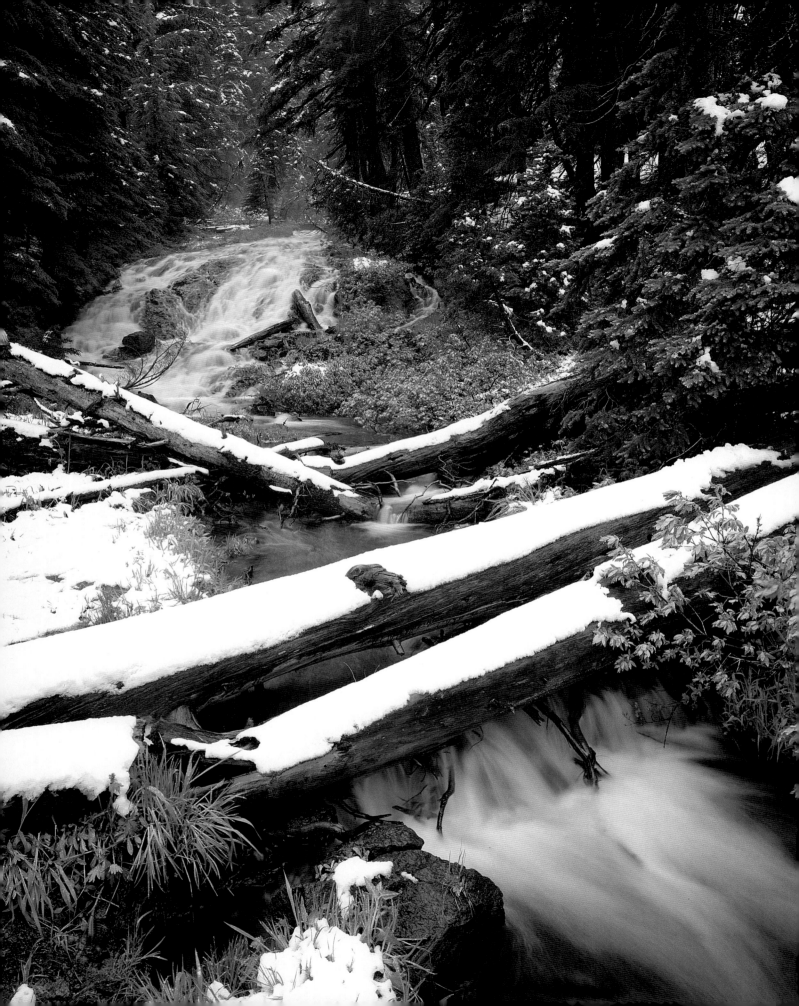

The fledgling government of the Oregon Territory attempted to deal with the "Indian situation" with an order by General John E. Wool, commander of the Army's Department of the Pacific. Wool issued a "non-settlement order" in 1856 forbidding emigrants to locate east of the Cascades. The Cascades, it was decided, was "a most valuable separation of the two races." The order was rescinded in 1858; the settlers were as unhappy about "containment" as the Indians.

In 1859, Oregon gained statehood, and in 1861 the nation became embroiled in the Civil War. Where whites found the most desirable land, they had rounded up the indigenous peoples, got them to sign treaties, and put them on reservations. But in the desolate wilds of southeastern Oregon, the Paiutes had been able to avoid early contact. Accustomed to living in small groups under trying conditions, they finally fought for what was theirs. Skirmishes and raids on ranchers and outposts terrorized the settlers and reservation Indians alike, and interfered with travel to and from the Canyon City mines.

By 1866, the Army organized campaigns to stop the Indian attacks. One notorious and feared Indian in the Oregon Territory was Chief Paulina, a warrior from the Walpapi tribe of northern Paiutes. During the constant struggle between the Paiutes and military, Paulina's wife and son were kidnapped by a quasi-military force and held hostage. Paulina sought their release at a peace meeting at Fort Klamath, but it brought fighting and more bloodshed. Pitted against him and dozens of bands of hostile Indians were various military leaders—among them, General George Crook. When Crook arrived at Fort Boise, Idaho in December of 1866, the situation was a shambles. He later wrote in his autobiography: "Indian affairs in that country could not well have been worse. That whole country, including Northern California and Nevada, Eastern Oregon and Idaho, up to Montana, you might say was in a state of siege." Crook, who had once led parties through the Cascades, met with more than Indian problems: vigilantes, desperadoes, refugees and deserters from the Civil War were swarming the region.

The Crook Campaign of 1867 set out from Fort Boise with Crook, his half-Indian scout Archie McIntosh, and troops that rotated in and out of the relentless fight against the small bands of Indians that attacked ranches and stagecoach stations. Crook zigzagged through Oregon and over the borders of Nevada and California killing and capturing Indians, including women and children. He finally got a peace treaty at Camp Harney in 1868, leaving the remaining Paiutes with no homeland, no reservation, and no hope.

Crook County is named after General Crook. Antelope area ranchers killed Chief Paulina in 1867. Paulina Lake and another dozen or so spots in Central Oregon bear his name. Historians in Jefferson County believe they have Paulina's knife on display at the Jefferson County Museum in Madras.

Six years after the Crook Campaign, some Paiutes joined the Bannocks in Idaho in another war that spilled into Oregon. The Bannock wars ended in 1878, and in 1879 a group of Paiutes, who had been moved forcibly from reservation to reservation, settled on the Warm Springs Reservation—home, too, for their long-time rivals.

While it is estimated that nearly two thirds of the Paiutes were killed during the Crook Campaign, disease, not war, nearly eradicated the region's Indian population. It is estimated that North Central Oregon Indian population of 10,000 was reduced to 2,000 during a period of fifty years from the time the white traders brought measles, smallpox, malaria, typhoid and cholera with them on their expeditions. Indians died in epidemic proportions from diseases for which they had no immunity.

Closer to the Cascades along the Deschutes River, settlement was more peaceful. In 1857, John Todd, came to Tygh Valley bringing cattle east of the Cascades. He built a toll bridge spanning the turbulent waters of the Deschutes and linking the gold mines of Canyon City on the John Day River and The Dalles on the Columbia River. Most travelers in the 1860s

TODD CREEK IN THE OREGON CASCADES IS TYPICAL OF MANY STREAMS AND RIVERS THAT DELIGHT RECREATIONISTS. CHARLIE BORLAND

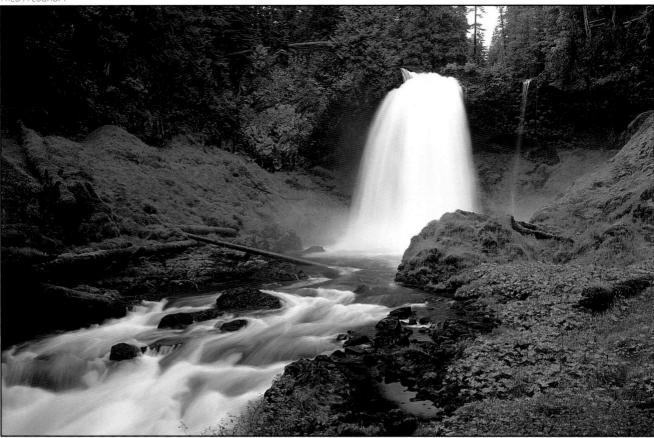

THE MCKENZIE RIVER ROARS OVER SAHALIE FALLS IN THE WILLAMETTE NATIONAL FOREST.

crossed Sherars Bridge. Todd eventually sold the bridge to Joseph Sherars in 1871, and moved to Farewell Bend where he started a ranch.

For decades, settlers with unimaginable fortitude cut through dense forests and treacherous mountains building roads over the Cascades. Many of the first roads followed Indian trails along ridges and high bluffs. Rough military and mining trails gained more regular use as thoroughfares across the High Desert. Beyond the roads' use by packstrings and military units, they were widened for wagons. With the wagons came families.

Because of the terrain, settlement of Central Oregon was slow. Originally, the region was Wasco County, a mammoth hunk of land that incorporated most of eastern Oregon.

In 1868, Barney Prine settled on the bank of the Crooked River where he built everything a town really needed in one small building: a blacksmith shop, store, and saloon with room for boarders. Soon, 200 people lived in Prine, its name changed in 1872 to Prineville. It wasn't to be a peaceful hamlet. This was one version of Central Oregon's wild west. Rough country with bluffs cut by raging river waters and driving winds, it drew men to match the landscape. By the 1880s, rampant lawlessness led to vigilante justice in which settlers took the law into their own hands. Lynchings and a state of terror permeated the region. In 1882, Crook County was established in part to bring the law closer to the center of the problem. But all was not lawlessness. The first school in Central Oregon was built on Mill Creek north of Prineville in 1868.

The Homestead Act of 1862 spurred settlement, but it was the Carey Act of 1894, with promises of water to irrigate the land near the rivers, that brought those whose dreams were rooted in the soil. The Carey Act allowed states to reclaim arid land through irrigation, turning sage lands into farm land.

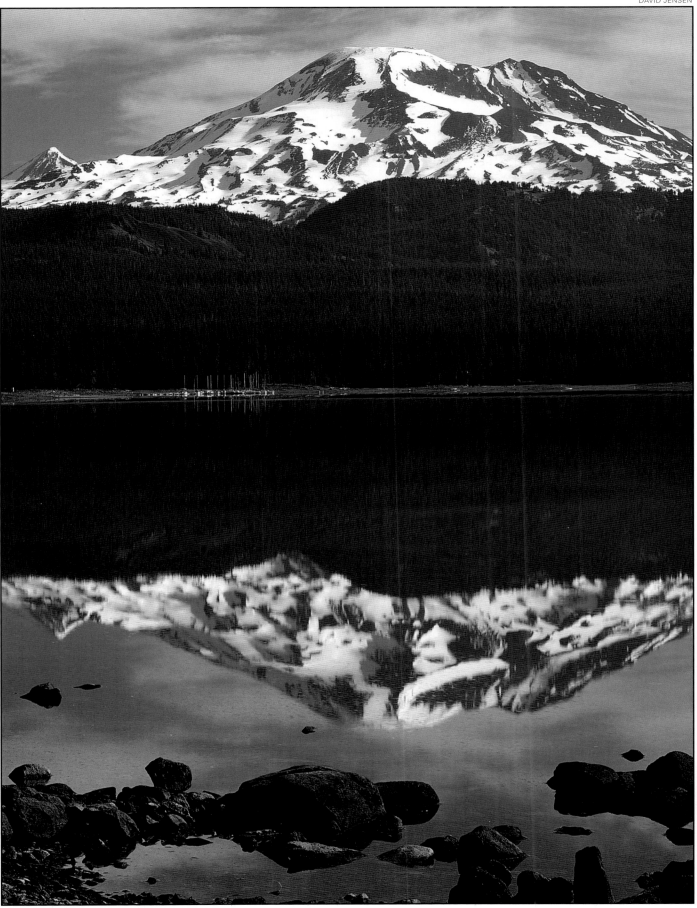

SOUTH SISTER MOUNTAIN VIEWED FROM ELK LAKE, DESCHUTES NATIONAL FOREST.

ABOVE: SPECTACULAR SUNSETS, SILHOUETTING THE SISTERS AND BROKEN TOP MOUNTAINS, REGULARLY OVERWHELM THE LIGHTS OF BEND. THIS VIEW IS FROM PILOT BUTTE.

FACING PAGE: "OLD RAILROAD DEPOT" IN BEND.

FRED PFLUGHOFT

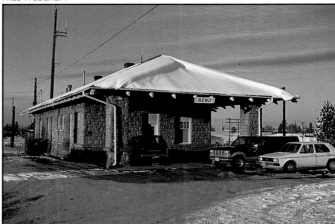

And then there were towns

The cities and towns of Central Oregon are as individual as sunrises. Built on the banks of rivers, on old crossroads or railroad lines, nestled in sheltered spots from desert heat or winter storms, they are lightly sprinkled across the landscape. La Pine, Tumalo, and Terrebone in Deschutes County; Culver, Ashwood, and Metolius in Jefferson County; and Powell Butte and Post in Crook County, each has a place in Central Oregon's past and present. The major towns—Bend, Redmond, Prineville, Sisters and Madras—offer some reasons why people congregated, built homes, businesses and churches and established population centers.

Bend

Bend is the metropolitan heartbeat of Central Oregon.

Originally a rest spot along the pioneer stage trail in the mid-1800s, it was called "Farewell Bend" for the bend in the river. The name was changed to Bend, then in 1903, changed briefly to Deschutes, and back again to plain old Bend. But the town is far from ordinary. Bend is growing up, and as residents haggle over the inevitable impact of more people and more services, the town is something like the baby born with a silver spoon in its mouth.

For Bend, the silver spoon is its location, a birthright of remarkable gems: rainbows that appear on winter days offering a slash of color against a snowy backdrop; mountains close enough to buffer winter storms yet far enough away to paint a panoramic view; a river that gently curves through town, allowing creation of a perfect pond; and a dry, sunny climate that beckons everyone to be outdoors.

A ritual of sorts goes on each evening in Bend. Dozens of people bid the day goodbye by hiking up Pilot Butte, the quirky, 500-foot cinder cone just two miles from downtown. From its rounded dome unfolds a circular view that reminds everyone of why they live here.

With a population of 30,630 plus another 10,000 skirting the city limits, it's the largest Oregon city east of the Cascade Range. Bend has been a mecca for early retirees, families, and singles looking for sunny skies, clean air, and more outdoor fun than any recreational junky could hope for. The population ballooned by more than forty percent from 1990 to 1994, but about half of the increase resulted from annexation of adjacent, outlying areas into the city.

Alexander M. Drake is credited with formally establishing Bend when he platted the town in 1903. He and his wife, Florence, moved from Minnesota in 1900, rolling into town in high fashion. They parked their luxurious wagon and set up camp along the banks of the Deschutes River. A large log home soon replaced the wagon, and Florence Drake matched the majesty of the setting by furnishing the house with Oriental rugs and antiques. Bend had one of its first "exclusive" homes and the beginning of its finest neighborhood.

Drake was wealthy in both cash and credit. He and another developer, C.C. Hutchinson, each owned irrigation companies and fought over rights to water from the Deschutes River. With his wealth and political connections, Drake obtained additional water rights by 1904, allowing him to take over Hutchinson's holdings. Drake formed his own irrigation system, COI Canal. His holdings included the Bend Townsite Company, two ranches, a sawmill, the A.M. Drake Company and its subsidiary, Pilot Butte Development Company. Drake's businesses diverted water to the arid land around Bend, provided the area's first electrical power, acquired property in and around Bend, and platted the town. In 1920, he sold his properties and moved to California.

The combination of railroads and timber gave Bend its first boom. The dusty little hamlet became the hub of Central Oregon when the railroad line was completed in 1911. As rail barons raced to finish competing lines, investors were buying up vast acreages of forest land for timber. Small mills sprang up and periodically burned, but in 1915 Brooks-Scanlon and Shevlin-Hixon both announced plans to build major mills. The agricultural community was transformed into a mill town. The population soared as the mills expanded. The two mills were some of the largest in the world, fed daily with giant ponderosa pines carried from the forest by rail logging lines to the millponds. "They logged this area like there was no tomorrow," a city planner said. But there's always a tomorrow, and when the mills began closing in the 1960s, Bend's economy slumped. The final mill closed in 1994.

The city center has always focused on the Deschutes River. At the south end of the city, the giant mills provided work for about eighty years. A dam slowed the river's meander through town in 1909, creating Mirror Pond. The loveliest and oldest neighborhoods hug the banks of the Deschutes. Swans and geese float serenely. City parks full of towering ponderosa pines provide public access to the prime part of the river. Mirror Pond, just west of the dam near Newport Street, is a shutterbug's delight. If you stand in just the right spot, you can look across the river and catch the snow-capped peaks of the Cascades that frame the city.

Mirror Pond backs up against the downtown area, making it a perfect pedestrian promenade. A parking lot was built between the downtown shops and the park, on the site of the demolished Drake home and several others. The parking lot, decorated with stone pillars, includes a public-gathering area. Ironically, one of the best views in Bend is from the parking lot.

At the far end of the parking lot is the Allen-Rademacher House. Community activists saved and restored the Arts and Crafts period home, converting it to the Mirror Pond Gallery and Coffee Shop and featuring works by Oregon artists. It is owned and operated by the Central Oregon Arts Association. Horse-drawn carriages take visitors on romantic rides around the pond and downtown area. It might not be New York City's Central Park, but it's safe to stroll around the area at night.

Each summer since 1982, the Cascade Festival of Music has enlivened Drake Park. Once

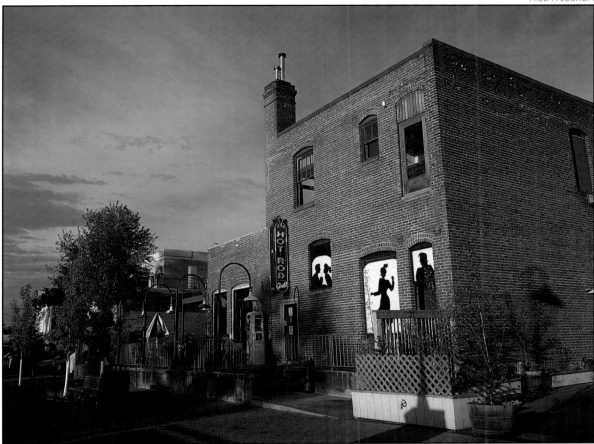

DOWNTOWN BEND IS AN ATTRACTIVE, UPBEAT BLEND OF BUSINESSES IN LOVINGLY RESTORED BUILDINGS, AS HERE AT THE HOT ROD GRILL AND BROOKS STREET PLAZA.

a three-day event of classical music, it has grown into a ten-day festival featuring the Cascade Festival Orchestra plus a variety of other performers. The people and businesses of Bend generously and enthusiastically support the festival. "Without the individual and corporate support of the people of Bend, we couldn't offer what we do at the reasonable prices we do," said Kip Narber, co-president of the festival. From a huge white tent, music flows through the park as sweetly as the swans on Mirror Pond.

Music doesn't end after the festival. For the six weeks that follow, a more casual affair goes on at Drake Park. Each Thursday night, residents and visitors throw down blankets and settle in to hear live music and eat from food booths set up by local restaurants. Aptly dubbed "Munch & Music," it is one of Bend's most popular free events and invigorates the city's social life. Toddlers tear across the lawn, teenagers hang out and grandparents discuss the latest grunge look. "How do they blow their noses with those rings pierced through them, dear?" Artists set up their wares, jugglers perform on the fringe and everyone glows in the warmth of community.

Festivals and music at the park are nothing new. In 1933, Bendites decided that Drake Park was the perfect setting for a Fourth of July water pageant. It was a success beyond anyone's expectations. Ten thousand people lined the banks of the Deschutes to watch floats and fireworks. It grew more extravagant each year, with a hiatus during World War II. Not all of the entertainment was planned. During the 1960s, a group of nudists invaded the pageant. The event (the water pageant, not the nudists' invasion) continued until 1965 when it ended with a decision that it had grown beyond control.

RIGHT: THE OLD REID SCHOOL BUILDING IN BEND NOW HOUSES THE DES CHUTES HISTORICAL CENTER.

BELOW: THE BROOKS-SCANLON MILL AND OLD LOG HOLDING POND ON THE DESCHUTES RIVER CONTINUE TO PLAY A MAJOR ROLE IN BEND'S ECONOMY.

FRED PFLUGHOFT PHOTOS

The downtown parks are only a few of the thirty-three parks and recreation facilities presently under the jurisdiction of the Bend Metro Parks and Recreation District. On the east side of town is Juniper Aquatic and Fitness Center with both indoor and outdoor pools, sauna, Jacuzzi and weight rooms. To the west along Tumalo Creek are Shevlin Park, with a stocked fishing pond for young anglers, and Aspen Hall, a 150-capacity facility with a lovely wrap-around deck and outdoor barbecue. A perfectly renovated barn is the center-piece at Hollinshead Park, where community gardens are part of the landscape.

Downtown Bend has defied the fate of many American main streets. Surviving the reces-sion of the 1980s, merchants and city planners looked at challenges of their expanding population and met them head on. Numerous discount businesses along the highways on the outskirts of the city seem unable to squeeze the life out of the downtown area. Local merchants roll out the red carpet for guests. Old-fashioned street lights line the two main downtown streets. During the winter, the trees and shop windows are decorated with thou-sands of tiny white lights. Upscale shops share the streets with older, traditional businesses. A favorite Bend haunt is the old Masterson-St. Clair Hardware store where you can still buy one bolt or dozens. Bend is the kind of town where the person who pumps your gas has a biscuit for your pooch.

There are dozens of restaurants, more per capita than any other place in Oregon. The Pine Tavern, a local institution, features traditional fare, but it draws crowds because of the huge trees growing through the Tavern's dining room, and because of the view it provides of the river and park with its profusion of flowers in summer and a Currier and Ives–like scene in winter. Live entertainment is offered at a number of clubs and restaurants. Brew pubs and coffee shops have found a breeding ground in the Northwest, and Bend is no exception.

There are more micro-breweries in Oregon per capita than anywhere in the United States. In 1988, the Deschutes Brewery & Public House opened its doors on Bond Street offering four standard brews, two that rotated seasonally, and two cask-condition ales plus a full menu. The brewery portion of the business outgrew its downtown location; a state-of-the-art brewery near the Deschutes River opened in 1993, expanded in 1995, and planned further expansion. The Deschutes Brewery distributes its beer in six states. It brewed about 1,800 barrels a month in 1995. The Bend Brewing Company opened in downtown Bend in 1995 giving beer connoisseurs another round of bitters, ale, and stout to choose from.

Cafe Paradiso, a downtown coffee shop and entertainment venue, is a funky respite after a tough day at the office or on the slopes. The Cafe opened in 1990 in a space that once housed a cinema.

Royal Blend, a local coffee roaster, is another spot to see and to be seen in. With three locations, it has the biggest slice of the coffee market in the area.

If people think all of this 1990s trendiness has pushed out the traditions of Bend, they need only show up for the annual Christmas or Fourth of July parades. Traffic is barred from Wall Street to accommodate any group willing to walk, ride or dance down the street to celebrate the holidays. Dogs dressed like reindeer and the aerobics class from the stylish Athletic Club of Bend share the street with the Deschutes County Historical Society patrons and truck after truck of Girl and Boy Scouts. The Christmas parade is topped only by the Fourth fun. The Lions Club serves up a pancake breakfast at Drake Park before hundreds of dogs and their owners, mostly kids, trot in a loop around downtown. There are a few ponies, and a goldfish has been spotted, but the parade is mostly mutts. Amazingly, there are few dog fights. Then it's back to Drake Park for live music, laughter and fireworks from Pilot Butte.

Among natives and newcomers, there is interest in keeping Bend the charming place they all know and love. Residents still smart from the 1973 demolition of a city landmark, the Pilot Butte Inn. Once a thriving hostelry, it fell into disrepair in the 1960s. After years of

battling to save the old stone and wood building, it was demolished. Its legacy now survives at the Athletic Club of Bend on Century Drive, where the fireplace was reassembled in the club's restaurant. The original cabin of Alexander and Florence Drake and the home of Klondike Kate were also lost as historic reminders to the citizens of Bend.

Other historic buildings are now being restored. Renovation of Heritage Square at the south end of Wall Street includes plans for a new library and facilities for the Boys and Girls Club in a restored landmark building, the Bend Amateur Athletic Club. The Des Chutes Historical Center occupies the renovated Reid School. The city bought the old Tower Theater on Wall Street to secure its future. Its doors closed to movie audiences in 1993, fifty-four years after it was built. In need of extensive renovation, the unheated building draws crowds for a wide range of public events including jazz performances and lectures by city planners—all part of an effort to raise money and show its value as a performing arts center.

The one-time mill town has an eclectic architecture. There are blocks of "mill shacks," built by mill workers with discounted or scrap lumber. And there are stately homes at Broken Top, a gated community west of Bend, and more high end homes on Awbrey Butte that borders Bend to the northwest. To the east of Highway 97, new subdivisions are filled with family-style homes and apartments with more proposed developments always on the drafting table. The gated, golf community of Mountain High flanks the southeastern edge of town.

Awbrey Butte is also home of Central Oregonians' favorite college, Central Oregon Community College. About one fifth of the high school graduates of the three-county area entering Oregon colleges headed for COCC in one recent year. That year, the school served more than 5,000 students in credit courses and another 10,000 in non-credit activities.

Founded in 1949, the 193-acre campus sprawls along the west side of Awbrey Butte. If the campus were sold as residential lots today, the view would make the property worth about a quarter of a million dollars an acre. Students trek through woods of juniper and pine trees with a panoramic view of the Cascades. Deer roam the campus.

Besides a stunning setting, COCC offers Associate of Arts degrees and professional/technical training in one- and two-year programs. It also offers some Bachelor's and Master's degree programs through the Central Oregon Consortium for Higher Education program whereby COCC contracts with other universities to deliver advanced programs. There are satellite campuses throughout Central Oregon.

Three high schools, four middle schools, and eleven elementary schools comprise the Bend–La Pine School District, enrolling 11,000 students in one recent year. The Oregon Educational Act for the 21st Century requires each district to design a curriculum to meet a set of goals for changing school operations. The Bend–La Pine District adopted plans to complete the changes in two phases ending in 1999. Anticipated changes include expanding preschool, blending some primary grade levels, and raising academic standards. By the end of the 1995 legislative session, some changes were made and some of the timelines rolled back.

The school district operates alternative education programs and a magnet school. High school students in the district regularly score higher than the national average on Scholastic Aptitude Tests. There also are seven private schools in the area.

Growth is the most hotly debated subject in town. Most visitors enter on Highway 97, also known as Third Street, which bisects the city. The strip of motels, restaurants, warehouse and discount stores and mini-malls is the first sight visitors encounter. At the north end of town is the stunning Central Oregon Welcome Center and Bend Area Chamber of Commerce offices where the staff annually sends out about 5,000 packets of general information and relocation information in response to inquiries. About 75,000 visitors drop in at the Welcome Center each year. About 50,000 cars drive down Highway 97 per day.

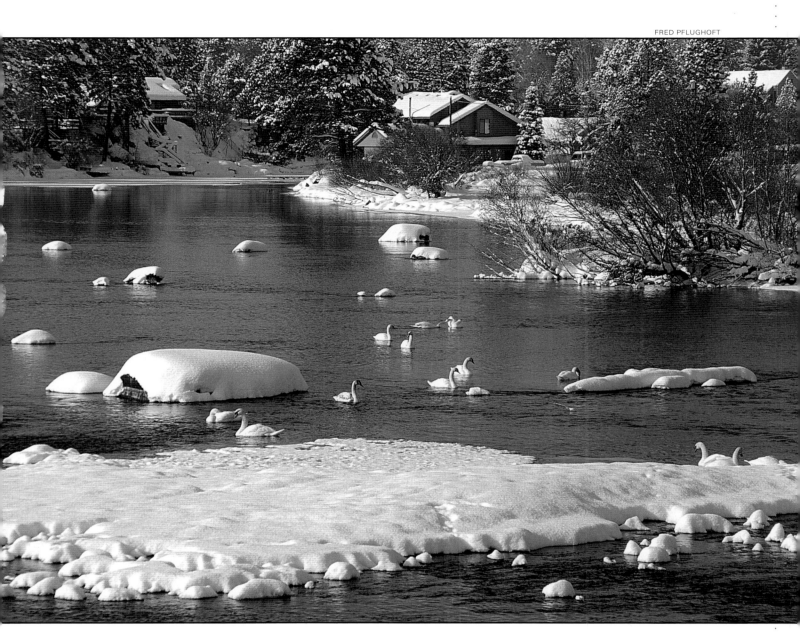

WATERFOWL ON MIRROR POND APPEAR TO BASK IN SUNSHINE ON FRESH SNOW.

Traffic snarls reached such a point that the city and state embarked on construction of a $90 million parkway replacing Highway 97 through Bend. Construction of the 7.2-mile parkway, accommodating bicycles and pedestrians as well as cars, began in 1988. Its proponents and opponents agreed that the parkway will change Bend forever.

Subdivisions surround the quaint heart of town. But developers, planners and other officials attempt to work together to assure sensible growth. Debates are frequent and heated over high-density versus sprawl development. The city, in rewriting its Comprehensive Plan, estimates that no zoning change would be needed to provide for an influx of 50,000 new residents. "Everyone wants to return to some idyllic place we thought we grew up in," said Mike Byers, city planner. "What we have to look at is what makes sense for economics and the changing lifestyles of the residents."

The development of the Crown Pacific mill site, a 200-acre swath of prime land on the Deschutes River, exemplifies a town in transition. Once one of the world's largest ponderosa pine mills, it closed in 1994. The developer envisions its transformation into a mixed-use neighborhood with shops, restaurants, and living units tentatively called the Old Millsite at River Bend.

The land can be seen from its developer's office window. In Bend, a reference to "Bill Smith's Place" does not mean the home, but the corporate office, of William Smith Properties Incorporated on the bluff above Shevlin Center. Grounds of the office building include a cascading garden, a spectacular sight in the spring. Not only is it a magnificent asset to the cityscape, but a great bit of public relations. What Smith, former executive with Brooks Resources Corporation, transforms this land into will have a major impact on the city.

MIRROR POND GALLERY, IN THE RENOVATED ALLEN-RADEMACHER HOUSE IN BEND, SHOWCASES WORKS BY OREGON ARTISTS.

Construction is everywhere. Replicas of the town's signature form of single family dwelling, the Arts and Craft Period bungalow, are being built on the northwest side close to the center of town. Multimillion-dollar gated golf communities, most notably Broken Top west of Bend, took form at the same time as a 70-unit apartment complex for low-income families funded by the Bill Healy Foundation filled up. More retail stores open every year, including mammoth warehouse and discount outlets, helping make Bend the regional shopping center for Central Oregon and beyond.

Ninety-five percent of Bend's population is white. The Hispanic population comprises 2.7 percent of the city's total while Native Americans, blacks and Asians each comprise less than one percent of the population. Even in this overwhelmingly white community, there is an awareness and appreciation of diversity and an effort to promote it. An annual Festival of Color in the spring offers a week of cultural events, "Honoring our similarities, celebrating our differences."

Myrlie Evers-Williams, chairwoman of the National Association for the Advancement of Colored People in 1995, is a resident of Bend. She commented when elected to the national post: "With a FAX machine and an airport, I see no reason not to run the NAACP from Bend." And she did.

BEND'S ANNUAL CHRISTMAS PARADE DRAWS CROWDS.

Beyond the Closet is a local organization that provides services to lesbians, gays, and their friends.

Programs for the physically and mentally challenged or centers for family services include the Rosie Bareis Family Center and the Kids Center, a Rotary Club project for child victims of abuse. The Central Oregon Family Support Program is available to families who have a member with developmental disabilities. St. Charles Medical Center, the regional hospital, is the largest acute care hospital east of the Cascades and has the region's trauma center. It is also the largest employer in Bend.

Whether it's hospice care or Habitat for Humanity, community involvement is at the crux of what works in Bend. The elected, seven-member city council and its city manager can count on a packed house for every meeting. Civic-minded residents can spend an evening hopping from an Environmental Center program on Kansas Street to the city commission meeting. "It's Bend's version of bar-hopping," joked a newcomer.

A group of devoted bicyclists has spent hours at city council meetings getting bike lanes approved so "every rider who wants to can ride their bike to work." More than 50 miles of bike lanes had been designated on Bend's main traffic routes by the summer of 1995.

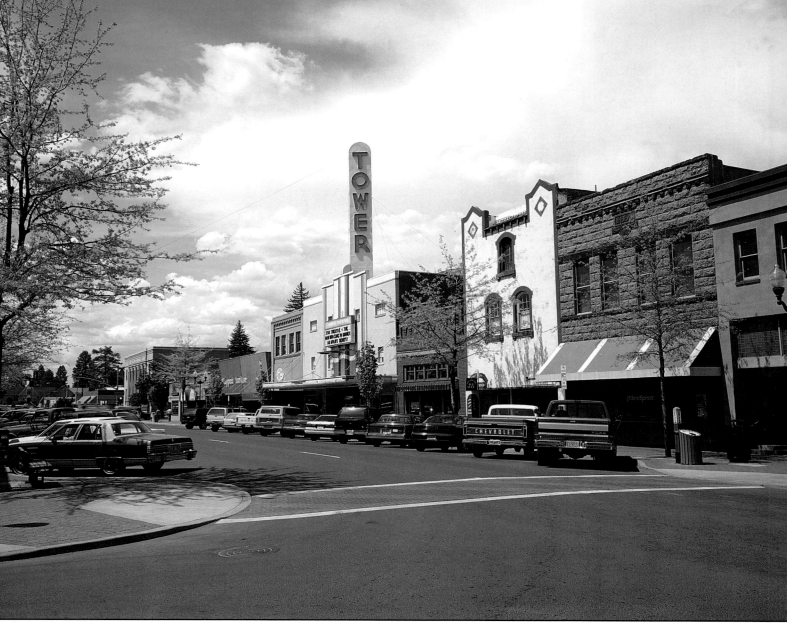

DOWNTOWN BEND VIEWED FROM THE CORNER OF MINNESOTA AND WALL STREETS LOOKING SOUTH ALONG WALL STREET.

When residents aren't in the great outdoors, they learn about it through extension programs from the University of Oregon and adult classes at COCC. Programs for bird watchers, environmentalists, and naturalists fill the community calendar. Party chatter is more likely to be about the High Desert reptile life than the latest film.

There are three movie theater complexes in town. If you want to learn about the land around you or be part of the planning for Bend's growth, there's a plethora of activities. And the dress code is always casual.

Bend is no cultural desert. The Community Theater of the Cascades has an intimate 125-seat stage on Greenwood Avenue. The Magic Circle Theater, part of COCC, also produces a number of shows each year. Children's Theater programs are held regularly at the Tower Theater, and other theater groups offer dinner theater productions at rotating venues. The Summer Festival in downtown is wildly popular, and artists and crafters fill downtown streets along with wineries, breweries and restaurants. The entire town shows up for the bi-annual Art Hop, when local galleries stay open and artists are on hand to demonstrate their crafts or to talk about their work. There are a dozen or so galleries and 16 pieces of public art in Bend.

But it's not too big a town to have its head turned by Hollywood. A number of western movies have been filmed in the area, and Clark Gable worked for Brooks-Scanlon mill in 1922, long before he "went Hollywood." When Tinseltown set up shop in 1994 to film a television series on a Tumalo ranch outside of Bend, hired locals as extras, and made sets of the Bend Post Office and a hardware store, then all nonchalance went the way of the lumber mills. Unfortunately, the best thing about ABC's "McKenna" was the local scenery and local talent. It bombed big time after three episodes, and has been seen infrequently since as a summer replacement series.

Not to worry. Residents of Bend need only look out a window to see the beauty that caught Hollywood's eye. And the storyline of living in Bend is far more interesting than any television script.

Madras

On the second floor of the Madras City Hall, circa 1917, is the history of Jefferson County. Much of that history centers on Madras, the county seat; the city named after a bolt of cloth; the sunny farm town that everyone goes through on their way to somewhere else.

"What's charming about Madras," comments a local resident, "is its lack of pretension. Madras is just Madras." That seems just fine with its 4,500 residents.

There are no huge warehouse stores or upscale tourist shops. No micro brewery or lush city park. There is The Stag restaurant featuring "family dining" and Charlie's OK Barbershop where Charlie Campbell has cut hair for more than a quarter of a century. Madras is the only place in Central Oregon where you can buy authentic Mexican pastries and groceries for a home-cooked Mexican meal. If you want to know what's really going on in town, there's the J&L Truck Stop and Cafe, but don't expect to be invited to sit at the center table, dubbed by locals "the table of knowledge." A select few old-timers discuss local and world affairs over coffee at the round table. The longest runway in Central Oregon is outside Madras, but there's no fancy airport terminal or dreams of commercial jet service.

It is a town where a day doesn't pass without just about everyone stopping to appreciate the sight of Mount Jefferson on the western horizon. Acres of subdivisions blend into the rolling hills to the east of town offering vistas of the High Desert as it collides with the Cascade Range.

If current residents put together a time capsule, it might be something like what you find on the second floor of city hall. "Well, it's not fancy," explains Aloha Kendall, a retired school teacher and the director of the Jefferson County Historical Society and Museum, who tends

to the place like it's her home. "But these weren't rich people." There are chairs once carried on the Oregon Trail, military and baseball uniforms, wedding gowns and the entire office of the town's former optometrist.

The history of Madras has been assembled informally from bits and pieces passed by word-of-mouth. The historical society is taking part in the Oregon State Homestead Register program to acquire information on homestead families. The town was established formally in 1911, but the first township deeds were filed in 1902. The oldest business is the *Madras Pioneer*, founded in 1902, and still putting out weekly editions. The oldest building is the Waymire House, built in 1884 and folks at the historical society figure there are about thirty houses still standing that were built before 1915. The Madras-Jefferson County Chamber of Commerce and Visitor Center is in a two-story structure built in 1917.

The town is governed by six city council members and a mayor with a paid city administrator overseeing day-to-day management.

Madras' claim to historic fame happened on New Year's Day in 1917, when a group of businessmen and ranchers took the county records from the then-county seat of Culver and deposited them in Madras. While Madras had won the hotly contested bid for the county seat, residents of Culver were none too happy. The entire episode would never have happened if Jefferson County had remained part of Crook County. In 1914 voters decided they wanted more control over their tax money; the new county court selected Culver as the temporary seat. The folks in Culver still smart from the seizure of the county seat almost eighty years ago.

No other place in Central Oregon can boast the ethnic diversity of Madras and Jefferson County. The school district here enrolls more Native Americans than any other race because the district includes the Warm Springs Reservation. There is a large Hispanic population, as well. Many Hispanic families, once relegated to migrant farm work, now make Madras their permanent home.

Ethnic diversity has been celebrated formally since 1994 in the Collage of Culture Festival. The event relies on a volunteer team and fourteen committees. Rob Fuller, executive director of Madras-Jefferson County Chamber of Commerce was instrumental in putting the 1995 event together. "It's part of our mission statement to appreciate our cultural diversity," explains Fuller. "And we do."

Fuller and others also celebrate the business potential of this seemingly sleepy little town. Bright Wood Corporation, one of the main employers in the tri-county region, employs more than 1,000 people. It is housed at the Madras Industrial Park, a joint venture of the town and county. The climate, availability of water and recreational opportunities could make it Central Oregon's next business mecca. Long an agricultural, cattle and sheep ranching community, Madras has seen change chugging its way like a locomotive.

When the Oregon Trunk Line completed its tracks to Madras on February 15, 1911, it was a major play in one of the country's last railroad wars. The multimillion-dollar race to secure a line from the Columbia River to the Deschutes Plateau south of Madras was between James J. Hill, builder of the Great Northern Railroad and the Oregon Trunk Line, and Edward H. Harriman of the Union Pacific and Southern Pacific. It was Hill's workers who built the seemingly impossible steel span across the Crooked River. At the time it was one of the highest bridges in the world—320 feet above the churning waters. It was Hill who drove the golden spike when his company arrived in Bend in October of that year.

Transportation continued to bring work and change to Madras. The Willow Creek Bridge was constructed in 1926, and U.S. Highway 97 was completed in 1929. But it was water that brought prosperity to the region. Early settlers had been blessed with damp weather and good crops. In 1913, the region got a permit to use Deschutes River water to irrigate 100,000 acres. Construction of a massive water project began in 1938, was halted during

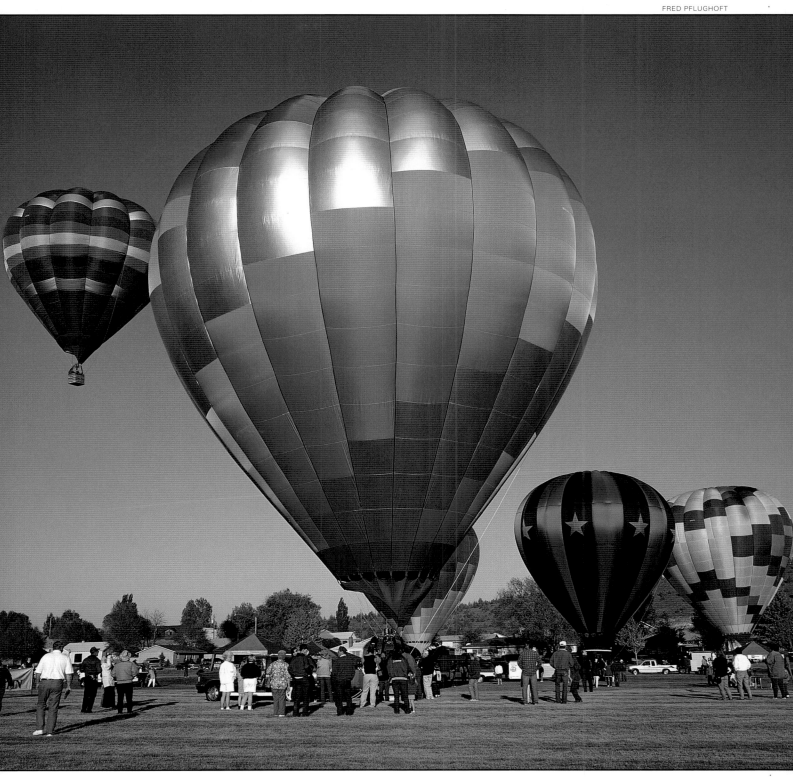

HOT-AIR BALLOONS HELP MADRAS CELEBRATE ETHNIC DIVERSITY WITH THE COLLAGE OF CULTURE.

the war, and completed in 1946. Today, there are two reservoirs that store water for the North Unit Irrigation District: Wickiup Dam and the Haystack re-regulating reservoir in addition to the Crooked River pumping station. Canals and laterals feed the water to the farms and towns of Jefferson County. Two additional dams, the Pelton and Round Butte, produced more than a facility for storing irrigation water.

The 204-foot Pelton Dam created Lake Simtustus, and the 440-foot Round Butte Dam created the ten-mile long Lake Billy Chinook. The two lakes draw 600,000 boaters and visitors a year. The Cove Palisades State Park near Culver offers campgrounds, boat moorage, fishing, house boating and water-skiing. Anglers enjoy the Deschutes River and hikers and hunters find plenty of open space on the Crooked River National Grasslands. During the summer, there are the Sports and Recreation Show, Rockhounder's Pow Wow, and Jefferson County Fair and Rodeo. Some of the best rock hounding in the state is found northeast of Madras. In the winter, skiers have their choice of going to Mount Bachelor, Hoodoo or Mount Hood.

Madras is part of a Jefferson County School District that serves Madras, Antelope, Metolius, Warm Springs and Simhasho. The high school, middle school, and elementary school are part of the district. A new middle school was completed in 1996.

Prineville

On the arid ranges in the eastern part of Central Oregon is the region's oldest town. Prineville sits in the Ochoco-Crooked River Valley. Once the site of range wars and Indian skirmishes, the town now serves as the Crook County seat. The shaded courthouse, circa 1909, dominates Main Street, and the A.R. Bowman Museum, at the corner of Third and Main streets, houses some of the rich history of this town of 6,500. Prineville was a ranching community until the late 1930s when lumber interests moved into town. Elisha Barnes, one of the settlers of 1867, was the first mayor. Today, the town is governed by a mayor and six elected council officials.

Not the tourist destination of Bend and Sisters, it is a feisty community that never says die. When railroad builders snubbed Prineville in 1910 in favor of Madras and Bend, Prineville built its own line. In 1916, Prineville voters approved two bond issues totaling $200,000 to finance the line they felt would ensure survival of the city. To this day, it is the only city-owned rail line in the country.

Two years later, the line connecting Prineville with the Oregon Trunk and Union Pacific lines, four miles north of Redmond, was completed. The hoped-for benefits were slow in coming. The city had spent a whopping $385,000 and it needed a return on that investment. It wasn't until the opening of two sawmills in 1937 and 1938 that the empty cars of the line's lean days filled with pine from the Ochoco Mountain forests. Unfortunately, the twenty years between the building of the line and this new need had left the rails in sad shape. With loans from the mills, new equipment was bought and the rail beds were rebuilt.

Today, many of the outlying mills that fed the rail line for twenty-five years are closed, but the railroad still connects Prineville-Crook County industry with main lines near Redmond and points east. The old working line gained another lease on life as the Crooked River Dinner Train that takes tourists from Prineville to Redmond with an array of entertainment options. Each December, Crooked River Railroad Company, operators of the dinner train, give the descendants of those who poured so much into the line a Christmas gift. Ten railroad cars, decked out in holiday lights and frou-frou, make the 19-mile trip to the delight of those who line the tracks.

Descendants of many early settlers still call Prineville their home. Names like Barney, Houston, Yancey, Roba, Powell and Sigman are in the historic records and current phone directory. They live here for the quiet beauty of the sun reflecting off an early morning frost

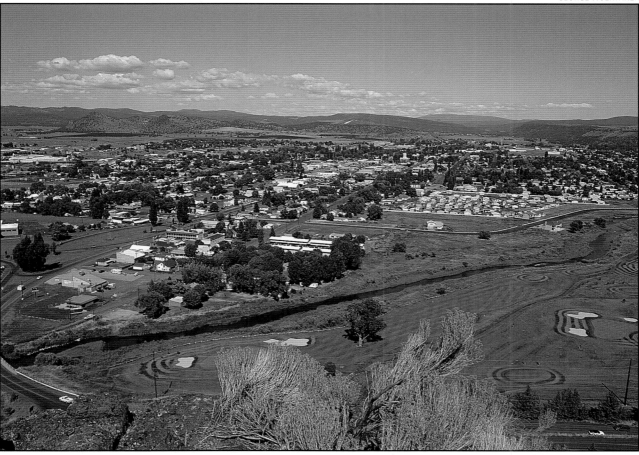

PRINEVILLE AND THE CROOKED RIVER VALLEY FRAMED BY THE OCHOCO MOUNTAINS.

across the golden rimrock bluffs that shelter the town. They find comfort in the sense of community, small town values, and small schools.

Newcomers settle in Prineville for some of the same reasons that have kept families here for generations with the added attraction of more affordable housing. But the median price of a home has escalated in recent years. Compared to prices in Bend, Prineville remains a relative bargain. The number of building permits also increased in recent years. Scott Cooper, executive director of the Prineville Chamber of Commerce, attributed that to pick-up from Deschutes County. "We don't have that much existing housing and we're backed up to farmland and wetlands, so growth will be in the outlying areas," he predicted.

There's one high school in the Crook County School District, one middle school and four elementary schools. The high school and middle school are, appropriately, on Knowledge Street. A new high school on Lynn Boulevard was scheduled to open in the fall of 1996. Central Oregon Community College and Oregon State University offer extension courses. But education goes far beyond the school system.

There are the lessons learned from riding a horse, raising stock or competing in rodeo events at the Crook County Fair Grounds built in 1904. Hundreds of kids are active in 4-H clubs. Then there's the fine hunting and first-class fishing on the Crooked River. Knowledge of favorite fishing spots is passed from generation to generation. The Ochoco National Forest, the Prineville Reservoir State Park, Crooked River National Grasslands and the John Day Fossil Beds are natural campuses for science, history, and, of course, recreation.

Fourth of July festivities with the Splash and Dash competition and fireworks followed

CROOK COUNTY COURTHOUSE IN PRINEVILLE.

by the week-long Crooked River Roundup are not-to-be-missed events. The Crook County Parks and Recreation District manages eleven parks; the oldest is the Ochoco Creek Park near the center of town.

The 18-hole city golf course stretches across the valley, a splash of grass that screams "green" in contrast to the pastel rock formations that surround it. More than golfers owe a debt to the links that were built as part of the city's $8 million sewer-improvement project. Those lush greens and fairways are there thanks to irrigation by effluent. Treated sewage water from the city keeps the course in top-notch condition year-round. "The government doesn't consider it a golf course at all, rather a waste water disposal site," says course manager, Wayne Van Matre. The chlorinated water is totally safe, but not quite drinkable.

In the late 1980s the recession hit Prineville with a wallop. Five of its seven sawmills closed, virtually shutting down employment opportunities in the lumber town. By the mid-1990s, fifty-two percent of the jobs were in manufacturing, and ninety-four percent of those were in timber products. The town's largest employer, and Central Oregon's sixth largest, is the world headquarter for giant tire service and distribution company, Les Schwab.

Two industrial-park complexes, one in the valley and another on elevated land by the airport are keys to the town's economic survival.

The Ochoco National Forest is another big employer. It is best-known for the Prineville Hotshots forest firefighters. Three hundred apply annually for twenty positions.

Because so many in the area have been Hotshots, and because the community is so tight-knit, the tragedy was intense in 1994 when nine Prineville firefighters were killed. They were fighting a fire in the rugged mountains near Glenwood Springs, Colorado. Twenty of Prineville's young fire fighters headed up the slopes to fight raging, out-of-control flames. Only eleven came out alive. With a total of fourteen killed, it was the worst federal fire-fighting tragedy of the century, and it left a scar on the little town so deep that some thought Prineville could never be the same.

News of the firefighters' deaths swept the town, enveloping it in numbness. Familiar names of victims brought the tragedy close. A memorial fund was started. "It [money] just started coming in," said Scott Cooper. "Eventually, over $73,000 arrived mostly in amounts of ten, twenty, and fifty dollars. Just very grassroots."

In 1995, plans were approved for a monument to all of the men and women who fight forest fires. The bronze Storm King Monument in Ochoco Creek Park shows two men and a woman in fire-fighting gear near a snag.

"It happened to Prineville and the state of Oregon," said Jill Hagen. "Many of our kids become a part of the Hotshots." Hagen and her husband, Doug, lost their daughter, Terri, a twenty-eight-year-old rookie firefighter at Storm King. "The monument is a tribute to all of our Hotshots," said Jill Hagen.

Redmond and Roberts Air Field

Tucked in the middle of the Cent-Wise Sporting Goods store was a lunch counter where coffee sold for a nickel a cup until the summer of 1995. Once a drugstore, the business attracted people with widely diverse interests. Retired ranchers, for example, frequently exchanged wit and wisdom with rock climbers. The food may have been microwaved, but the atmosphere was pure, old-time Redmond. The marquee outside still reads Cent-Wise Drugs as it has for nearly fifty years that it has been family owned and operated. In the early 1990s, owner Vern "Pat" Patrick, "saw the writing on the wall," and sold his pharmaceutical interests to a chain. He moved the hunting and fishing inventory from his adjacent hard-ware store, but kept the lunch county in place. His sons now run the business.

The dismantling of the lunch counter was a sign of the times in Redmond. With a growth rate of ten percent annually, some things have to change. "It was kind of like tearing a piece of my heart out, but it was the right thing to do," laments Patrick. But what doesn't seem to change is hard-working, civic-minded people who love the town where they live. Vern and Madeline Patrick are just such Redmonites. He ran the volunteer fire department for fifteen years, and she worked at the store while raising four sons.

To Vern Patrick, involvement makes Redmond. "The neat thing about Redmond is if you have a worthwhile civic project to do, you can get a bunch of guys together and get it done." Civic projects include the bleachers at the high school, a $100,000 job completed without a cent of tax money, and the $200,000 raised by the Kiwanis Club in the 1970s to build the indoor swimming pool and another $43,000 to run it before there was a parks and recre-ation department.

Like Vern Patrick, Redmond is a no-nonsense kind of place. It was founded in 1904 by two school teachers from North Dakota, Frank and Josephine Redmond. They were farmers dedicated to irrigating the rocky, sage- and juniper-covered terrain. The couple acquired their plot of land as part of the Carey Act, then waited for the water.

Irrigation canals started flowing in 1904 north and east of Bend off the Deschutes River.

The Pilot Butte Canal, started two years later, brought a waterway through Redmond. New life gushed into the land. Farmers cleared the rugged terrain and planted clover, potatoes and alfalfa.

The railroad gave Redmond another lifeline. The trains first came from the north in 1911 across the still impressive steel span over the Crooked River Gorge. Redmond was incorporated in 1910.

Redmond, with a population of about 11,000, sits at the junction of Highways 97 and 126 on a flat stretch of land with a pristine view of the Cascade's Three Sisters. The two main streets are the north and south arteries of Highway 97, making up the downtown district. Renovation of historic buildings is ongoing, and it is becoming a center for antique hounds. Children attend one of six elementary schools, two middle schools or Redmond High School.

The town has twenty-nine churches and several public recreational facilities: an indoor municipal swimming pool, tennis courts and an 18-hole golf course. But it is the natural playground, like all of Central Oregon, that Redmondites enjoy. Hunting, fishing, hiking, rock climbing, skiing and other winter sports are all a short distance away.

Come August, the Deschutes County Fair draws 150,000 to 160,000 visitors during five days of festivities. Potatoes once were the pride of Redmond and prolific production spurred the first Redmond Potato Show and County Fair in 1919.

Livestock competition was held in Bend into the 1920s, then moved to Redmond accompanied by a name-change for the event to Deschutes County Fair.

If Prineville got its reputation from building its own rail line, Redmond looked skyward. Redmond bills itself the "Hub of Central Oregon," and the airport complex east of town is a big part of that claim. Roberts Field underwent a $3.9 million expansion in 1993 that tripled existing terminal space. In 1994, the airport boasted the highest growth rate of any airport in Oregon.

As planes land on the 7,000-foot runways, it's unlikely that the passengers know that volunteer labor created the first landing strips. It was a different kind of "Roaring 20s" here. The lure of airplane engines whining in the sky caught the imagination of the Redmond Commercial Club and American Legion post. They platted a site, paid for it and hand-cleared the rugged land. By 1929, the field was ready. When runway extension was needed, Redmond citizens again volunteered their labor and equipment. In 1941 the airfield was named after J.R. Roberts, the man who spearheaded the dream of a first-class airport at the "Hub of Central Oregon."

In summer, the airport complex comes alive with smoke jumpers and air tankers. The Redmond Air Center has been the base of U.S. Forest Service fire suppression and fighting activity since 1964. A regional fire training center, it has storage facilities for retardant, seven to nine aircraft tankers and tools and equipment for 3,600 firefighters. Workers at the complex respond to an average of 700 fire incidents each season. Hotshot crews and pilots are also trained at the complex.

The Yew Avenue exit off Highway 97 to Roberts Field leads to a thousand-acre industrial zone surrounding the airport complex. Lancair International, producing sleek, single-engine airplane kits, and Cascade Lakes Micro Brewery were among the first occupants on the land that was once open livestock range.

Sisters

Twenty miles north of Bend is the quaint town of Sisters. It's the gateway to the Santiam Pass, Metolius River, and Hoodoo Ski Bowl. Nestled in the western portion of Deschutes County, surrounded on three sides by national forest, and at the foot of the Cascades, Sisters is one of the most beautiful locations in Central Oregon. With a few more inches of precipi-

WARM COLORS IN THE WEATHERED BARN WOOD AT CLOVERDALE RANCH NEAR SISTERS ARE WELCOME ON A JANUARY AFTERNOON.

tation a year than neighboring Bend or Redmond, it is a patch of sunlight in the pine forest.

This town is a mecca for tourists. At the intersection of three highways, the beauty of its setting is not all that draws the crowds from nearby Black Butte Ranch resort and elsewhere. It is the western, theme-park architecture. What looks like an old-fashioned town of the 1880s, is really the late-1960s brainchild of developers of Black Butte Ranch, Brooks Resources. Seeking a shopping destination for guests, the resort offered up to $1,500 to every shop owner in Sisters who would adopt a western storefront and sign. The idea took hold like a bronco rider at the Sisters Rodeo. Western storefronts dominate three parallel streets. A strict commercial building code enacted in 1975 limits buildings to two stories, allowing only the ponderosa pines to tower over the buildings. The city's landscape management plan protects the trees. Who would ever guess that this town wasn't officially incorporated until 1946?

Real pioneers passed through Sisters en route to the Santiam Pass over the Cascade Range. The first settlement was a short-lived military outpost at Camp Polk about four miles northeast of Sisters. The post office at Camp Polk moved to Sisters in 1888. Sheep ranchers were drawn to the area, and in 1901 a plat was filed to establish the town of Sisters. Small mills opened, but the town took a population dive when the last mill closed in the early 1960s. Redirection of Sisters as a tourist destination defined the town and the entrepreneurs who settled here.

Nearly all of the sixty shops are owner-operated. Non-polluting, light industry is encour-

SISTERS RODEO FANS START YOUNG.

aged to locate in the Sisters area, where two industrial subdivisions exist. National companies like Questar Publishers and Metabolic Maintenance products, a vitamin company, are headquartered here. Sixty percent of the town's operating budget comes from taxes generated from local business. "This is a town where people came to visit and tried to figure out a way to stay," explains Jim Fisher, manager of the Sisters Chamber of Commerce.

If Sisters' architecture is extraordinary, then the predominant livestock species in the community keeps pace. Llamas are the stock of choice here. Say "llama" and everyone thinks "Sisters." The first llamas in the area were on the Richard Patterson Ranch. In 1968, 500 llamas were in the herd. When the Pattersons divorced, they split the herd. Now Sisters may not have the single largest llama ranch, but the "largest concentration of llamas" in Oregon with the Patterson Ranch west of Sisters and Kay Patterson's Hinterland east of town.

Sisters' population is only about 800, but more than 6,000 people live within ten miles of town in places like Tollgate, Crossroads, Squaw Back, Indian Ford, Black Butte Ranch and Barclay Place.

The highly acclaimed Sisters School District operates an elementary school and a new combined high school and middle school. Housing is pricey by Oregon standards, and small cabins and cottages within the city limits often are on land that is far more valuable than the structures. Sisters is run by a hired city administrator and five-member council.

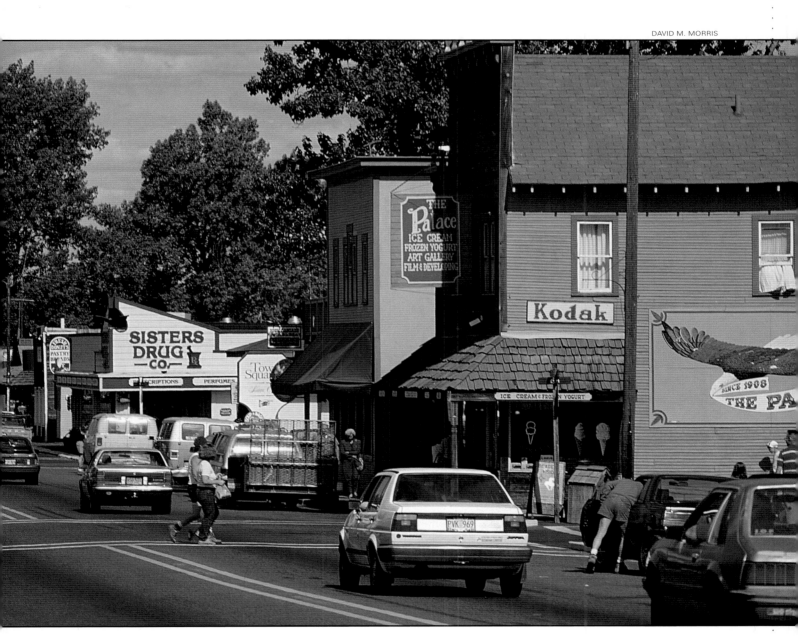

ALL COMMERCIAL BUILDINGS IN SISTERS HAVE THE LOOK OF THE OLD WEST.

An infrastructure that has not kept up with the town's growth is a problem. The city's comprehensive plan notes a need for additional street lighting and parking. There is no sewage treatment plant and not a large enough tax base to finance one. Portable toilets are strategically placed for tourists, but the needs of thousands of visitors who come to town on a typical summer day are barely met by these and the individual septic tank systems.

Robert Grooney runs the corner Gallimaufry store and has watched Sisters' growth for more than twenty years. "It amazes me to see what happened and [it is] exciting to see what else is happening," he says of the boom. Grooney is one of the dozens of people working to solve the problems that popularity has brought to town. Those who live on the outskirts contribute to Sisters through volunteerism and civic work. It has become a thriving arts community with special events to meet the needs of cowboys, tourists and transplanted urbanites.

One of *Sunset* magazine's eight best tourist-destination towns in America in 1993, Sisters has found its niche. Countless towns have come to community leaders with visions of replicating the success of the Sisters transformation. "They have to find their own niche," says Fisher. "It's a combination of a lot of good luck and hard work."

Metolius Valley and Camp Sherman

Ten miles north of Black Butte in Jefferson County is the Metolius Basin. Here the head-waters of the Metolius River gurgle from the ground. It is the beginning of one of the finest flyfishing rivers in the region. The valley floor is surrounded by ridges with Black Butte rising to the south. The three-mile-wide valley is close to the foot of the Cascades, and forests are thick with towering ponderosa, larch, fir and cedar trees. Aspen, willows, and birch sprout in the lower wetlands. There are no golf courses or tennis courts, and tourists who seek out the treasures in this valley check their stress at the door of the nearest cabin.

Around 1911, the first vacationers started congregating here, finding a respite from the heavy work on the surrounding wheat farms. They rolled in with horse-drawn wagons and fished along the banks of the Metolius River. Since many were farmers from Sherman County to the north, someone nailed a sign with the name Camp Sherman to a tree at a fork in the road. A store opened in a tent and a permanent building constructed in 1917. The Camp Sherman Store and Post Office is still the center of Camp Sherman social life. A restaurant rounds out what the little hamlet's residents and visitors need. Today, a picture-perfect group of cottages is across from the general store. About 200 people are permanent residents in Camp Sherman.

Land is leased from the U.S. Forest Service for seasonal residents. The Wizard Falls Fish Hatchery, where the Oregon Department of Fish and Wildlife raises 2.6 million fish annu-ally, is nearby. It is at the bridge to the hatchery that the waters of the Metolius turn a milky turquoise, a shade that must be seen to be believed.

THE MUSEUM AT WARM SPRINGS IS AN ATTRACTIVE FACILITY FOR PRESERVING THE TRADITION AND CULTURE OF THE REGION'S NATIVE AMERICANS.

FACING PAGE: WARM SPRINGS ON THE SPRAWLING WARM SPRINGS INDIAN RESERVATION.

DAVID JENSEN

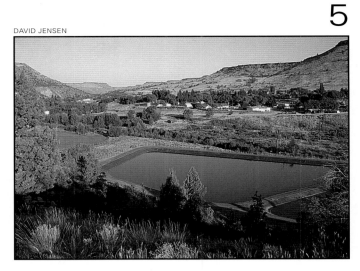

The Confederated Tribes of the Warm Springs Reservation

It was sizzling hot on the final day of the Pi-Ume-Sha Treaty Days Celebration at the Warm Springs Reservation. But participants weren't shedding the traditional garments as they moved into the arena for the grand entry. Layers of fabulous beadwork, jangle bells, and feathers adorned the dancers. The color guard was first, with veterans and flags and the oldest of the elders, Grant Waheneka, setting the slow, mesmerizing pace of traditional dance. Tipis, campers, and tents surrounded the park by the community center, where food booths and vendors with beads and jewelry and dream catchers were selling their wares.

The pageantry and celebration offered a hint of the heritage and spiritual legacy that stretch back to the "time beginning." What happened only one hundred and forty years ago from the day of the Pi-Ume-Sha celebration says much about that heritage and people of Warm Springs.

On that day in 1855, the Superintendent of Indian Affairs Joel Palmer, told a group of eighty-nine men representing bands of the Walla Walla and Wasco Tribes that they were to move onto this land, with agreed-upon boundaries and stipulations. There would be a formal agreement using legal principles of ownership—a treaty that both the Indians and white government would live by. The traditional Indian laws, practices, and relationships from hundreds of generations would be altered forever. The Indian representatives weren't surprised. The trickle of whites they had openly greeted and freely traded with had turned into a torrent, and the Indians were obviously in the way.

"The place that you have mentioned I have not seen," said Chief Mark, a representative of the Dalles band at the treaty meeting. "There are no Indians or white men there yet, and that is the reason I say I know nothing about that country. If there were

Indians and whites there, then I would think it was a good country."

Obviously, this was not land the settlers coveted. The government wanted the Indians to become farmers, but only a fraction of the 640,000 acres was suitable for agriculture; much was desert and the rest forests and mountains. The reservation was bordered by the Deschutes and Metolius rivers and the ridge of the Cascade Range beginning near Mount Jefferson going north to Clear Lake Butte then east to the Deschutes. It excluded the Columbia River, home of many of these bands and the lifeblood of Indian food and culture, salmon. The Indians secured the right to fish the Columbia, pick berries, and dig roots in other ancestral lands, but the river would not belong to them. It would belong to the newcomers.

The reservation's first school building, a makeshift affair, was built in 1874. Later, boarding schools were built where Indian children, forcibly separated from their families, were dressed and taught the ways of white people. In 1887, Congress passed the Dawes Act, allowing the original reservation land, meant to be held by the Tribes, to be allocated and owned by individual Indians. Not only did individual land-ownership conflict with Indian culture, but the new law left vast acreages open for purchase by non-Indians. A disputed portion of land, the McQuinn strip, finally was added to the reservation in 1972. The federal government's misguided Indian policies are the subject of volumes, and while tribal leaders continue to work to protect treaty rights and sovereignty, they don't dwell on past indignities.

The land that the U.S. government didn't want is now a place to rebuild Indian culture and heritage and conduct independent business and tribal government. In 1937, the three Tribes organized as the Confederated Tribes of Warm Springs Reservation of Oregon. The move was taken three years after the Indian Reorganization Act, which was meant to make tribes into self-governing communities. Warm Springs is one of only three reservations in the United States that is exempt from Public Law 280, which means that the State of Oregon has no legal jurisdiction on the reservation. The Warm Springs Reservation has its own constitutional form of government and is a federally chartered organization.

"The organization was built on the way the treaty was negotiated," explains Jody Calica, general manager of Warm Springs Natural Resources and a treaty scholar. "Trust, negotiation, and equal partnership. We never went to war, were never conquered, there were no terms of surrender. We work from the good neighbor partnership approach."

That philosophy may explain why The Confederated Tribes of Warm Springs is Oregon's largest and most economically successful Indian group. The Tribes now own all of the land on the reservation. Major development of Warm Springs' natural resources began in 1942, when The Confederated Tribes signed their first contract for timber sales. In 1967, they approved a twenty-year contract to cut 500 million board feet of timber. The Tribes later purchased a sawmill and plywood plant to process the reservation's timber.

In 1957, the Army Corps of Engineers completed the Dalles Dam on the great Columbia River, and it wiped out the salmon harvest at Celilo Falls. It was one of the most devastating, modern-day governmental decisions to affect the Northwest's Indian population. The insatiable need for power ended centuries of Indian tradition and food harvest. The federal government paid the Confederated Tribes $4 million to partially compensate for the loss.

The Tribes could have allocated the money among tribal members, but instead it made a major decision. The money went into the tribal treasury, and the Tribes contracted a study of the reservation's resource and economic development potential by Oregon State University. In 1969, the Tribal Council adopted a comprehensive plan. The Confederated Tribes of Warm Springs would take charge of its own future.

When they began to reap the benefits of capitalism by developing the reservation's natural resources, it was to raise the reservation's standard of living. As the 1970s ended, the Tribes' prosperity and various enterprises made it the largest employer in Central Oregon.

During this time, Vernon Jackson and Ken Smith were prominent leaders within the Tribes. Smith, the Tribes' second college graduate, worked forty years for the Tribes until resigning as chief executive officer and secretary-treasurer at age 60.

The Tribes' portfolio of major business interests included: Kah-Nee-Ta Resort; the Pelton Reregulating Dam Hydroelectric Project, a $30 million hydroelectric plant; Warm Springs Apparel Industries; Warm Springs Compost Products; three radio stations; Warm Springs Forest Products; the Museum at Warm Springs; and Warm Springs Plaza, the first phase of a three-part retail project.

The Early Childhood Education Center has day care and primary school classes plus educational facilities to accommodate up to 420 children. It is state certified and licensed. Families pay on a sliding scale, from nothing to about a dollar an hour.

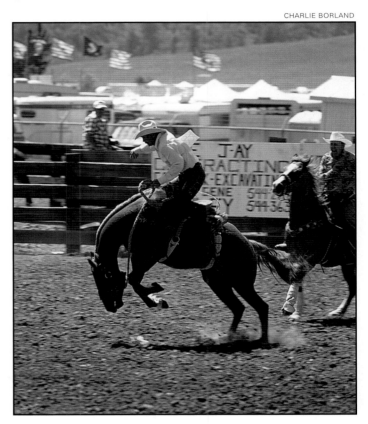

CHARLIE BORLAND

The new Health and Wellness Center is in a modern, sprawling structure with a 110-member medical staff on-call 'round the clock.

Most of the Tribal Council offices are in an attractive, wooden administrative building with panoramic views of the bluffs and hills of Warm Springs. A large wall plaque lists all tribal members who have earned undergraduate and graduate degrees.

Louie Pitt, Jr., director of governmental affairs and planning, talks about the complexities of tribal government and traditional ways. All tribal members are considered owners of the reservation. In business terms, they have a stock in the corporation that is Warm Springs. In traditional ways, according to Pitt, "ownership" means a stewardship of gifts from the creator and responsibility for caring for them. "We must mesh ancient values with contemporary issues," says Pitt. To Pitt, this is not only a natural approach, but also a successful one. "I think the Indian approach to business is wonderful."

BRONC RIDER AT THE TYGH VALLEY ALL-INDIAN RODEO.

Those ancient values come up in every conversation about the past and future of the Warm Springs Reservation. Whether it is Pitt or Jody Calica, the conversation always comes back to the land. "Spiritual teachings say to take care of the creations, and they will take care of us," Calica said.

The current mandate is for the reservation to integrate ecosystem management. The Tribes joined with the Environmental Defense Fund in the early 1990s in an effort to build consensus on environmental issues between the Tribes and neighbors in the Deschutes River Basin. The consensus was documented in the Integrated Resources Management Plan of 1992. Permeating the leadership is a strong sense of the Tribes taking the reins on policy issues, not the federal Bureau of Indian Affairs or any other federal agency.

Fiscal savvy is another hallmark of the Tribes' leadership. The prospects for new business, including gambling at Kah-Nee-Tah resort, excite Charles Jackson, general manager of business and economic development. The Warm Springs Tribes, long holdouts on gam-

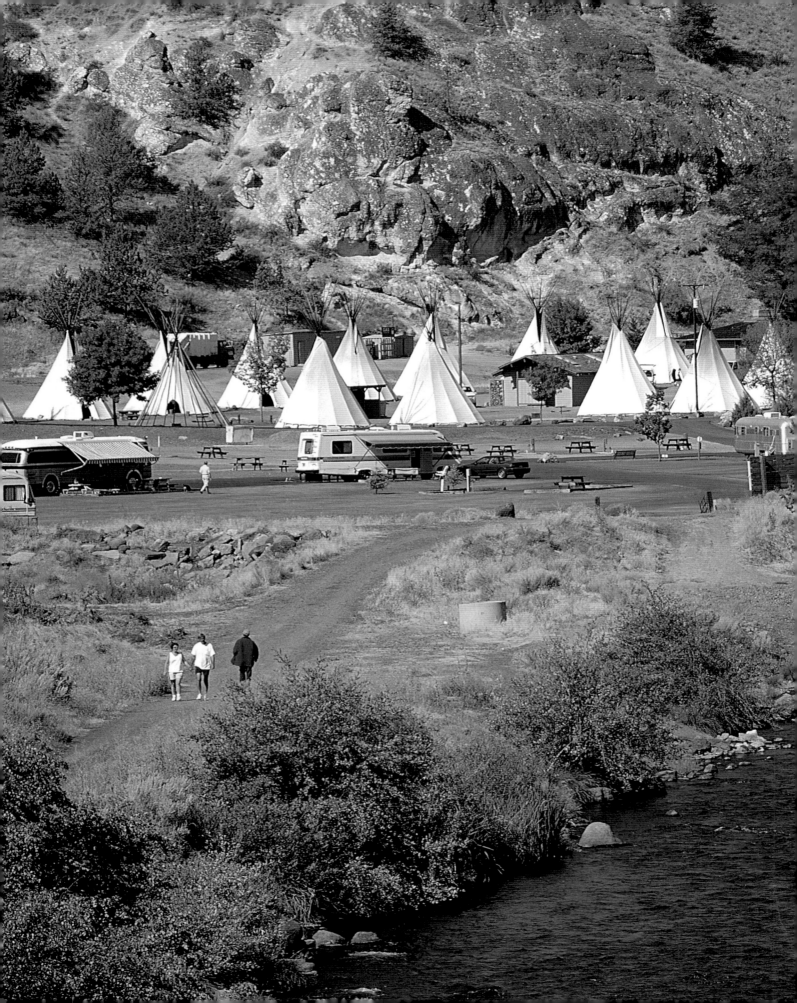

bling, became the eighth of the nine Oregon Tribes to sign gaming pacts with the state. As Jackson put it: "Some of the more adventurous pushed it, and the reservation came together to change some attitudes. When they finally got it to a vote—it took some doing to get it to a vote—it passed overwhelmingly." The $8.5 million gambling center was expected to earn $7 million annually. While other Oregon Tribes operate casinos, the Warm Springs facility is the only one financed entirely by the Tribes, thus avoiding outside management fees.

As with other timber interests in the Northwest, Warm Springs is dealing with a decrease in available timber and the ensuing layoffs at its forest products facility. The plywood portion of the operation closed in the fall of 1991. With reliance on natural resources shifting, the Tribal Council is focusing on restoring the land and water and promoting individual business ownership.

At the same time as the Tribal Council is promoting business, it is emphasizing the Tribes' histories. That history is displayed at the Museum at Warm Springs. Two decades ago, the Tribes saw the physical relics of its history leaving the reservation. Private collectors and institutions off the reservation were buying family heirlooms. Financially strapped families and those who wanted security for their heirlooms and keepsakes sold them. In 1968, the Tribal Council began to allocate $50,000 each year to purchase artifacts. The Tribes also have a valuable collection of photographs and documents dating from the 1850s.

The Tribes' $7.6 million museum is in a remarkable building set in the cottonwoods along Shitike Creek off Highway 26. It provides an emotional journey into the past through its natural setting and its displays of symbols of Indian culture. Visitors start in a cavern-like space surrounded by reproductions of pictographs and sounds of the culture. The museum emphasizes tribal elders and their oral histories. The importance of ceremonies is conveyed through dioramas of rites of passage. Artifacts and heirlooms are treated like treasures.

The history of Northwestern Indians after their contact with Euro-Americans is told through displays of historical documents, photographs, artifacts, firsthand accounts and an overview of the Treaty of 1855. It tells of the struggle of the relocated Tribes to survive the demoralizing effects of Americanization. Border disputes and the loss of traditional ways are shown, including loss of the power to educate their own children. Pictures of Indian children with their long hair bobbed, dressed in silly knickers and blouses, taken in front of the boarding school, are heartbreaking for any parent to look at. It is quite a juxtaposition to the three large-scale re-creations of traditional dwellings—a Paiute family wickiup, a Warm Springs tipi and a Wasco plank house.

Today, education is a primary concern on the reservation. With the Early Childhood Education Center and reopening of an elementary school a reality, many of the tribal members are focusing on the possibility of a reservation high school. Sixteen to seventeen percent of the Indian high school students currently drop out of school; some think a tribal school would curb the trend. Despite the dropout rate, more Warm Springs Reservation high school graduates recently have gone on to higher education. Of the twenty-five who graduate in an average year, about eight go on to college.

The Tribes don't leave learning only in the hands of academics. The Culture and Heritage Department takes an active role in devising curriculums and implementing programs for both children and adults. Three longhouses on the reservation are sites for traditional festivals, feasts, and ceremonies. There are a number of Christian churches on the reservation, but services for the Washaat religion are held at the longhouses, the traditional spiritual center of the reservation. Legends, chants, and dancing are important ways of keeping the culture alive. More difficult is saving the languages of the Tribes. Melding spiritual traditions, respect for the environment and economic progress is a potent combination for the Tribes of the Warm Springs Reservation.

A TIPI VILLAGE IS PART OF THE KAH-NEE-TA RESORT ALONG THE WARM SPRINGS RIVER. DAVID JENSEN

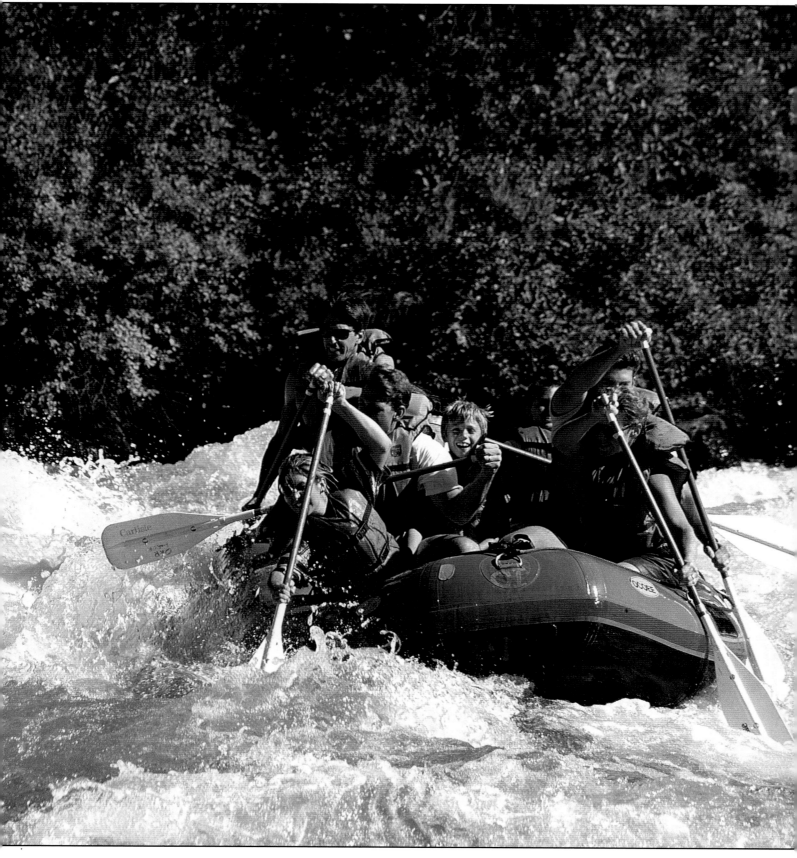

ABOVE: RAFTING "BIG EDDY" ON THE DESCHUTES RIVER.
FACING PAGE: FLYFISHING ON THE SANTIAM RIVER.

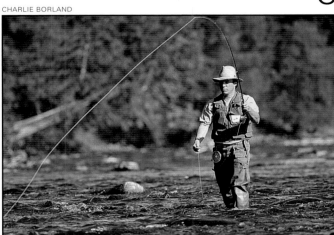

6

Fun and games

Forests, rivers, and mountains are only minutes from the doorstep of any Central Oregonian's home, so it's not unusual to have locals divide their time between jobs and an outdoor fix—whether it's fishing, hiking, biking, rock climbing, kayaking or skiing.

It seems everyone in Central Oregon drives some type of four-wheel-drive utility vehicle equipped with a system to attach bikes, kayaks, skis or other implements of outdoor fun. And nobody wants to be left behind: three-wheeled strollers, backpacks, and bicycle trailers are full of kids ready to get an early education in Recreation 101.

It is an immense classroom. There are 1.6 million acres in the Deschutes National Forest, keeper of much of the eastern slope of the Cascade Range. Eighteen state parks, national monuments, grasslands and numerous city parks and recreation districts offer everything from rock climbing to bird watching.

For the most vigorous, there's the Pole Pedal Paddle. Each May since 1977, downhill and Nordic skiers, bicyclists, canoeists, kayakers and runners have tested their skills over a single course. Truly serious competitors do the entire course solo, others work in relays.

The six-segment race begins at the base of Mount Bachelor and ends at Drake Park in the center of Bend. At first, just a few hundred athletes were game. Now, two- to three-thousand participants take over the mountain, roads and Deschutes River for a day of pure pleasure—or pain.

Pole Pedal Paddle draws thousands for a single event, but millions of visitors come to Deschutes National Forest to enjoy recreation without a competitive edge. The forest is divided into three ranger districts: Bend-Fort Rock, Sisters, and Crescent. Like all National Forests, it has been struggling with a shrinking budget, new land-use regulations and a changing attitude about public land. Concessionaires run

many campsites in Deschutes National Forest, and 1,200 volunteers supplement regular staff in an effort to keep top-notch interpretive programs going and grounds maintained.

During the summer, 7 million people use the forest—another million in winter. There are 1,300 miles of trails, over one hundred campgrounds, six wild and scenic rivers, five wilderness areas, Mount Bachelor Ski Area, nearly 350 miles of snowmobile trails, numerous lava caves and the Newberry National Volcanic Monument.

The Cascade Lakes Highway, a designated National Scenic Byway, is the main thoroughfare to this region. The highway opens in late spring and closes in October; you can meander along the road heading out of Bend on Century Drive and stop to hike, picnic or just gawk along nearly 100 miles of road that take you in a circuit back to Bend. If there is one perfect introduction to the Cascade portion of Central Oregon, this is it. As you climb the highway toward Mount Bachelor you pass charred remains of the 1989 fire that threatened Bend, and lava flows that cut a swath through the forest. The forest makes subtle changes as lodgepole and ponderosa pines give way to white mountain hemlocks and other coniferous trees. Snow-capped peaks of the Cascade Range are a constant backdrop to the evolving scenery.

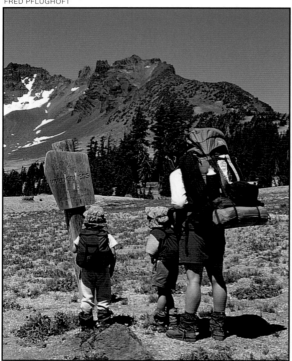

FRED PFLUGHOFT

FAMILIES ENJOY BACKPACKING IN THE THREE SISTERS WILDERNESS.

A favorite stop for those who want an easy walk is the trailhead at Todd Lake, a few miles past the exit to Mount Bachelor Ski Area. Todd Lake is set in a meadow that can be teeming with wildflowers and tiny frogs. Circled by pines, the crowning glory of the setting is Broken Top with its glacier-carved peak, a reminder that more than volcanoes created this landscape.

A few miles farther up is Sparks Lake, a lesson in evolution of natural lakes. Set against the backside of Mount Bachelor, this sprawling lake is slowly filling with sediment from wilderness streams and tributaries, changing it from a mountain lake to a meadow.

Trailheads to the Three Sisters Wilderness area that straddles the Deschutes and Willamette National Forests are off the Cascade Lakes Highway. Green Lakes trailhead is one entry to 283,402 acres of Three Sisters Wilderness with 111 lakes and over 400 miles of trails. While it may be a wilderness area, it is hardly unused—100,000 people visit the area annually: backpackers, packers with stock or saddle livestock and day hikers in the summer, and Nordic skiers and snowshoers in winter.

For water sports, Elk Lake, farther west, is a mecca for wind surfers and sailors. The fun and funky Elk Lake Lodge has a soda fountain, formal dining room, fishing supplies and advice. Canoes, paddleboats, and rowboats along with cabins are for rent.

Six more lakes are right off the scenic byway, where canoes glide across pristine spans of water. Hosmer, Lava, Little Lava and Cultus lakes are a few that invite camping, hiking, and fishing. Dozens of other lakes are a day-hike away. Crane Prairie and Wickiup reservoirs are favorite fishing spots.

Rangers and volunteers from the Bend-Fort Rock District host a variety of interpretive tours and campfire programs each summer.

Many of these bodies of water have one common draw—fishing. Eighty percent of those

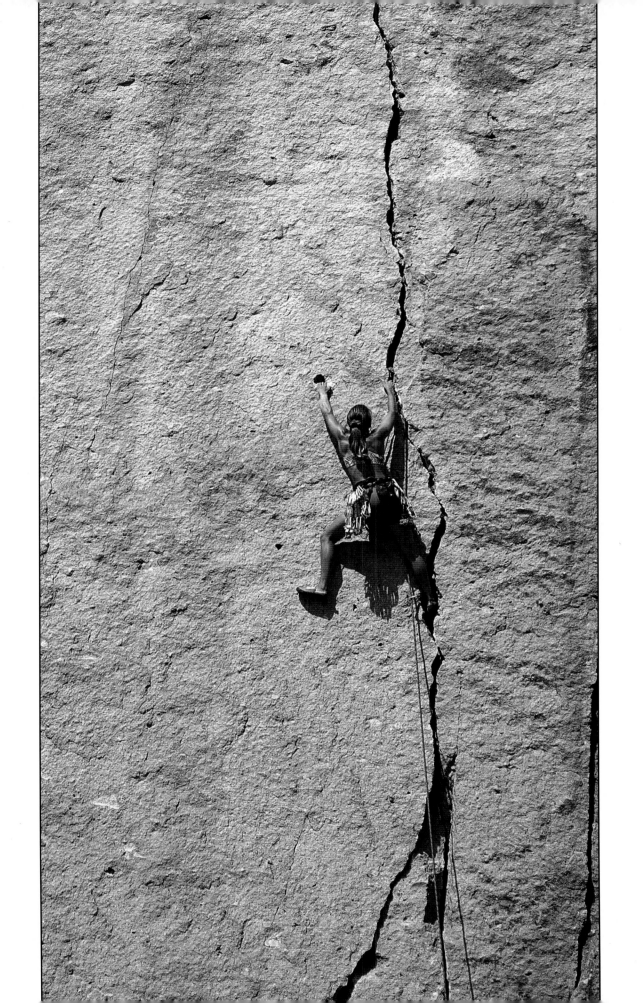

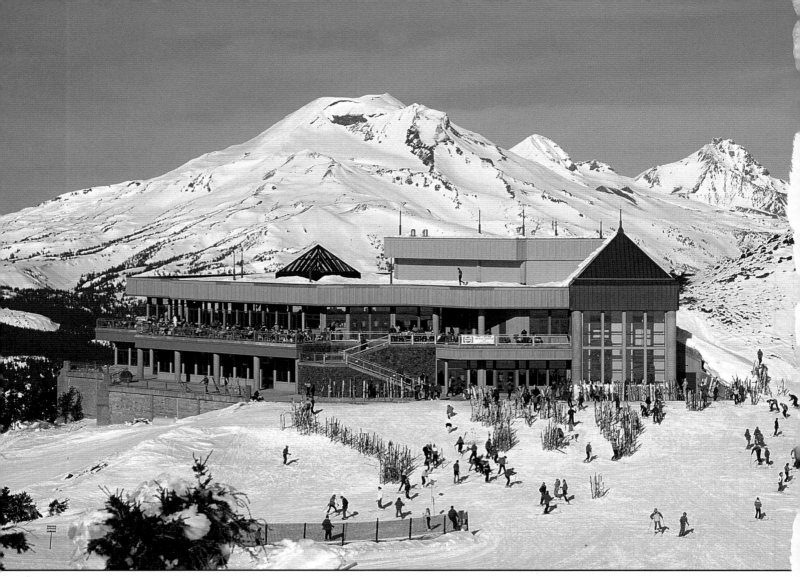

PINE MARTEN LODGE, MOUNT BACHELOR. LYLE COX

who step onto the National Forest lands are ready to wet a line on one of the lakes, streams or reservoirs. Things have changed since 1907, when the daily trout limit was 125 fish, but it's still a trout angler's haven.

Crane Prairie Reservoir is one of the region's hottest fishing spots. Created in 1929 as a water source for arid farm land, it is located off the Cascade Lakes Highway as the road descends out of the mountains. The five-square-mile reservoir is full of native and stocked rainbow and brook trout and a growing population of bass. When the water flooded over stands of trees that were once along the Deschutes and Quinn rivers, resulting snags made for good insect and fish habitat, and the area became a significant breeding ground for osprey or fish hawk.

About six miles south of Crane Prairie is Wickiup Reservoir. At full pool, the 10,000-acre reservoir is the largest of the Cascade lakes and abundant with rainbow, brook, and huge brown trout. Kokanee, coho salmon, whitefish and chub are also caught here.

Then there is stream fishing. It is a sure sign of spring to catch sight of an angler whipping a fly line over the waters of one of three main rivers in Central Oregon: the Deschutes, the Metolius, and the Crooked.

"If I had only one river to fish, the Deschutes would be it," wrote Harry Teel, a retired engineer, fly fishing shop owner and author. Thousands of fishing enthusiasts agree. Head-

waters of the Deschutes are at Little Lava Lake about twenty-five miles southwest of Bend. Two hundred fifty-two miles north, after thrilling anglers, kayakers, rafters, canoers and hundreds of people who seek solace in its rumbling path, the Deschutes spills into the great Columbia River.

The Deschutes, named by French-Canadian trappers, who dubbed it "La Rivere des Chutes," is as varied as the terrain it travels through. The river is divided into four segments: the Headwaters, from Little Lava Lake to Wickiup Dam; Upper, from the dam to Bend; Middle, from Bend to Lake Billy Chinook and Lower from Pelton Dam to the Columbia River. Designated a federal Wild and Scenic River and State Scenic Waterway for most of its length, the river begins smoothly meandering through pine forests and meadows. Wildflowers cover the banks after the snow has melted. Families like fishing along the river above Crane Prairie, giving their kids a beginner's chance to catch something. More experienced anglers hack their way through underbrush and wade into their favorite spots. The methodical whipping of fly lines is the only sound accompanying the rush of water.

As the river heads toward Bend north out of Sunriver, it follows its steepest path, a basalt channel, before plunging over Benham, Dillon, and Lava Island falls. Hiking and biking trails run along this portion of the river. Both fishing enthusiasts and kayakers are challenged by the forces of water, rock, gravity and a variety of aquatic species.

The Deschutes belongs to everyone as it winds through the center of Bend, caught by dams and gently swirled into Mirror Pond, the visual center of town.

Fishing season on the Upper Deschutes is from late April through October, but from the north dam in Bend, anglers may fish for trout year-round. While most of the Upper Deschutes is accessible and on National Forest land, the Middle portion passes through Bend then changes to a wild, raging canyon river. The Deschutes cuts through private land, but there are three state parks with campgrounds along this stretch where the river takes on yet another personality before being dammed at Lake Billy Chinook.

Cove Palisades State Park is part of Lake Billy Chinook. The 3,906-acre lake offers a sun-drenched set-

McKENZIE PASS CYCLISTS; NORTH SISTER MOUNTAIN ON THE HORIZON.

ting for a multitude of water sports including fishing for salmon and bull trout, houseboating and water skiing. Here the Deschutes joins the Metolius and Crooked rivers then flows into Lake Simtustus. From Pelton Dam, it widens dramatically. Flowing through lands under diverse ownership and regulation: the federal Bureau of Land Management, the Confederated Tribes of Warm Springs, the Oregon State Parks and Recreation Department, two railroad companies, and numerous private parties. Awareness of changing regulations along the course of the Deschutes is one of the "rights of passage" for its recreational use.

The Metolius River headwaters is set in a stand of old-growth ponderosa before a spectacular meadow with glacier-clad Mount Jefferson in the background. Here, the spring waters gurgle to the surface, then roll through the forest and weave across a meadow before heading north. Five miles off Highway 20 near Camp Sherman, there are paved pathways to the headwaters. The twenty-mile river also has been designated a Wild and Scenic River

and predominantly a fly-fishing stream for catch-and-release only.

The Crooked River cuts through bluffs in the High Desert. The river is open year-round, and most trout fishing is done outside of Prineville.

Where the Crooked River winds through Smith Rock State Park northeast of Bend, there's a playground for those who prefer to dangle from pinnacles of ancient basalt than to angle for trout. The tops of these fantastic crags can be seen from Highway 97; a turn east at Terrebone takes you to this world-class climbing destination.

Towering above the slow-moving river are reddish tuff cliffs, interspersed with harder rock fragments. Only ten years ago, the cliffs and spires of this area were relatively unknown to climbers outside the Northwest. The first documented ascent at Smith Rock was in 1935. Recent climbers blazed dozens of new routes, giving them names like *Monkey Face*, *Rattlesnake Chimney* or *Lion's Jaw*. To the non-believers standing below gaping at Lycra-clad climbers, the more appropriate names are *I Almost Died*, *Brain Salad Surgery* and *Grand Illusion*.

Climbers are adamant that the sport, when done properly, is relatively safe. But gurneys lashed to first aid stations at the base of the cliffs are a reminder that precautions should be taken seriously.

Whitewater rafting and kayaking are both popular sports. The Forest Service issues permits to three professional rafting companies on the Upper Deschutes, where about 600 people enjoy a float on a typical July or August day. There are probably a hundred or more outfitters working the Lower Deschutes. Individuals with their own rigs usually opt for lower stretches of the Deschutes, McKenzie or Umpqua rivers. Kayakers, who can more easily carry their boats, take on challenges like Big Eddy Rapids on Upper Deschutes. Thrill-seeking kayakers are the sports car drivers of the water.

While some ride rapids, others ride the rodeo circuit. Central Oregon has a long history of ranching and rodeo competition. Two major events are the Sisters Rodeo and Crooked River Roundup at Prineville. Sisters is the larger of the two events and draws about 6,000 spectators each night of the three-day event.

Horseback riding at one of the region's equestrian centers or along the bluffs and rimrock is slightly more tame, but most riders in these parts are usually on two-wheeled steeds. There has to be a bicycle for almost every resident of Bend. Hundreds of miles of trails stretch along rivers, through woods and town, around lakes and craters, and up and down mountains. The Cascade Cycling Classic takes place each July, bringing top names in bicycle road racing to Central Oregon.

Not every jock in Central Oregon goes for adrenaline-rush kind of sports. Not with twenty-one golf courses stretching out fairways like extended fingers through the pines and sagebrush. This may be the High Desert, but you'd never know it by the lush, irrigated links built to challenge the most demanding golfer. Sixteen of the courses are public, with the remainder private or semi-private, giving a grand total of 342 challenging holes. Established in 1927, The Bend Golf and Country Club is the oldest golf club west of the Mississippi. One of Central Oregon's newest courses, the 18-hole Crosswater course at Sunriver Resort, was named the nation's best new resort course of 1995 by *Golf Digest* magazine. "The environment here in Central Oregon for golfing is as pure as you can get from the first of June to the later part of October," says Jim Wilkinson, head golf professional at Bend Golf and Country Club.

What makes this area such a draw for golf are the clean air, high altitude (the ball carries about 10 percent farther), reasonable green fees. And sunshine. Nothing ruins a golf vacation faster than an afternoon rain.

In spring, it's common for skiers returning from a day on Mount Bachelor to pass golfers teeing up on the Robert Muir Graves-designed Widgi Creek Course on Century Drive.

Ah, yes, skiing. If the summer is delightful, winter is spectacular. What greater thrill than

LEFT: SNOWBOARDER CARVES A ROUTE DOWN MOUNT BACHELOR.

BELOW: CONTESTANTS ARE BUNCHED AT THE START OF THE NORDIC EVENT IN THE GRUELING POLE PEDAL PADDLE COMPETITION.

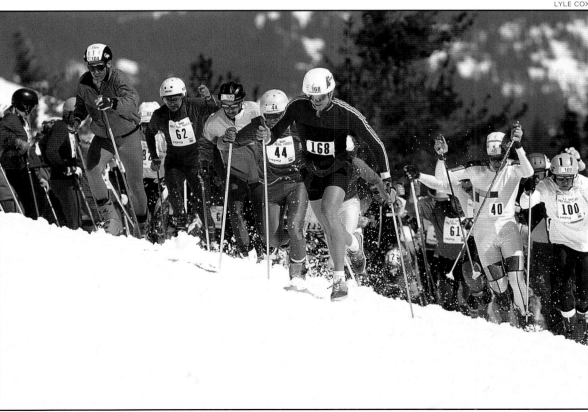

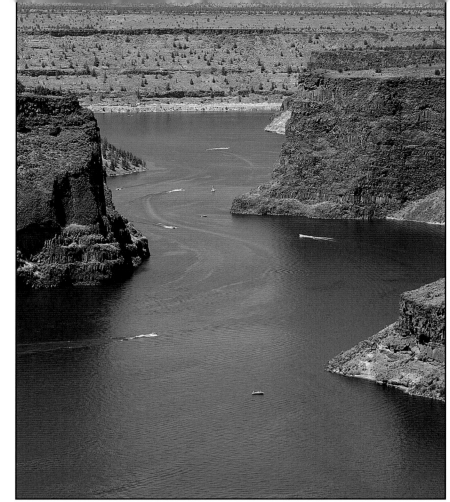

JON GNASS

RIGHT: A SUNNY MORNING IN JUNE REWARDS BOATERS ON LAKE BILLY CHINOOK IN THE COVE PALISADES STATE PARK.

BELOW: A BOAT DOCK ON ELK LAKE WITH MOUNT BACHELOR IN THE DISTANCE.

DAVID M. MORRIS

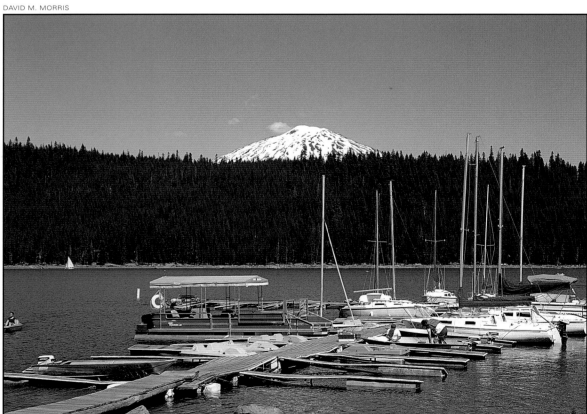

sliding off a chairlift or pushing off on a Nordic trail, and being privy to miles of perfect snow conditions? All of the violence of the mountains' creation is cloaked in the veil of winter.

Many seekers of winter's outdoor life often begin at the Mount Bachelor Ski Area, twenty-two miles west of Bend. The area offers downhill or Nordic skiing and snow boarding to 600,000 enthusiasts a year. Thirty-one-hundred vertical feet of slopes and bowls plus a snow boarder's park make up Mount Bachelor's downhill ski area, with another fifty-six kilometers of groomed cross country trails. A computerized ticketing system, ten chair lifts (including six express lifts making for short lift lines), various lodges and an average annual snowfall of 250-300 inches make it a world-class resort. The season usually starts before Thanksgiving and closes on the Fourth of July. Add snowshoeing, dog sledding, nearby snowmobile parks and nature hikes, and, well, you have it all.

The Mount Bachelor Ski Area has a special use permit for 8,060 acres of Deschutes National Forest Service land. Plans have been approved for a new lift on the backside of the mountain as viewed from Sparks Lake which would open 122 additional acres of ski runs and make it the longest vertical lift on the mountain.

The partnership agreement between Mount Bachelor Ski and Summer Resort and the Deschutes National Forest makes this more than a ski area. In 1990, an interpretive and environmental education program was started at the area. If this doesn't sound as exciting as schussing down a slope, you just haven't tried it. Forest Service volunteers take groups—

free of charge—out on the mountain on three types of tours: snowshoe, Nordic and alpine. A booth on the lower level of West Village Lodge is open with up-to-date information.

Snowshoeing through fresh powder with giant flakes falling around you is to step back in time. Clad in state-of-the-art snowshoes (lent free to all participants), then treading between huge mountain hemlocks laden with snow, it's easy to cast yourself in an old Jack London yarn. The ranger's voice explaining the world hidden beneath all of the winter covering, identifying trees and animal tracks, is a gentle nudge back to reality.

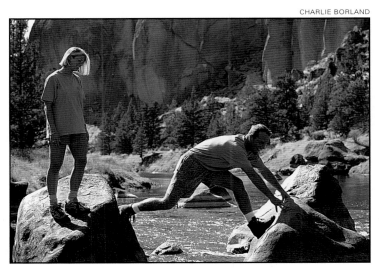

SCRAMBLING AMONG RIVER ROCKS ENLIVENS A HIKE.

There are Olympic skiers, competitive cyclists, top-notch golfers, rodeo circuit cowboys, but for the simple joy of a bleachers seat, brewski in hand, and a seventh inning stretch, there's the Bend Bandits. In the spring of 1995, the new independent Western Baseball League debuted the Bend team. Central Oregon has a long history of baseball. By 1910, every little town had its own baseball team and the rivalry that went with it. Mills and other businesses sponsored semi-pro teams during the 1930s and early 1940s. In 1946, the ball park, now the Vince Genna Stadium, was built. Take a seat behind home plate, and you not only get some exciting ball and bizarre promotional events, but you also can catch the sun dropping behind the Cascade Range beyond the outfield wall.

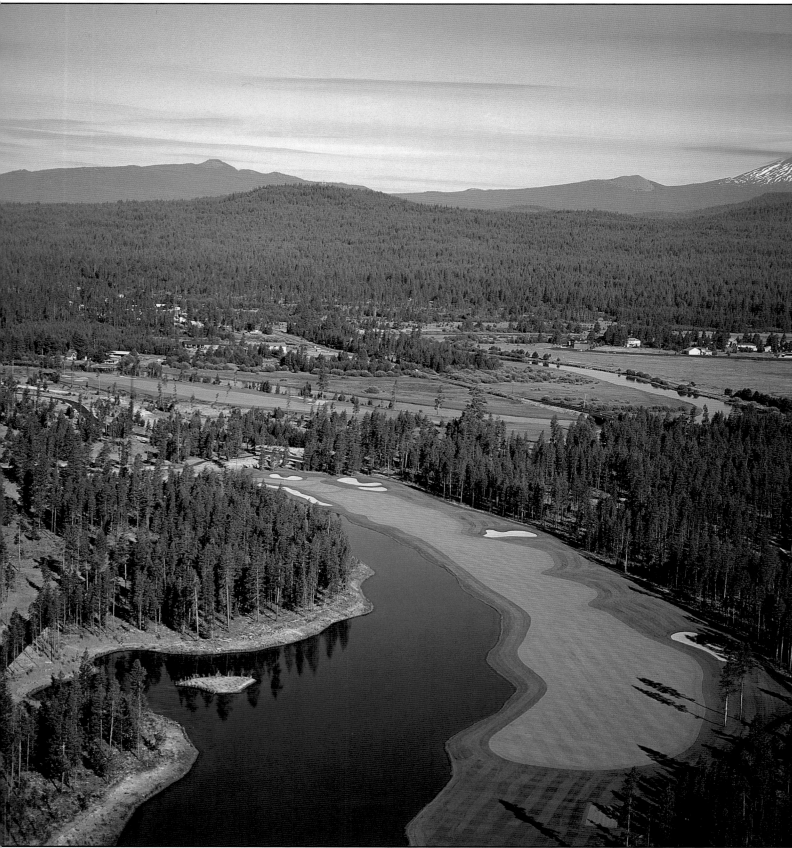

ABOVE: THE 12TH HOLE AT CROSSWATER, SUNRIVER RESORT, NAMED BEST NEW RESORT COURSE IN THE NATION BY *GOLF DIGEST* IN 1995.

FACING PAGE: SHOOTING FOR THE SECOND HOLE ON THE COURSE AT EAGLE CREST RESORT.

FRED PFLUGHOFT

Destination resorts

Three-and-a-half to four million people visit Central Oregon annually, spending more than $236 million. Many of them head for destination resorts. When you ask people where they vacation, the answer often is Sunriver Resort or Black Butte Ranch.

There are fifteen "resorts" in the three-county area that include charming, smaller getaways like Rock Springs Guest Ranch between Bend and Sisters, but it's the half dozen large, full-service destination resorts that helped put Central Oregon on the map.

• *Black Butte Ranch*—In 1881 a small cabin on Glaze Meadow near the base of the densely forested Black Butte was the only structure for miles. Today, part of that meadow is the Glaze Meadow golf course, one of two courses at Black Butte Ranch. Located thirty-one miles northwest of Bend and eight miles from Sisters, it is a resort and residential community of understated architecture that quietly blends with nature's backdrop.

The multi-leveled lodge is full of cozy, cushioned spots in which to curl up and gaze at mountains, lake, meadow, and forest. Condominiums are clustered on the eastern edge of the meadow, and you might not even notice the homes built across the meadow. Nestled in the trees are more than 1,200 lots—most with completed homes. One main road winds through the neighborhood dotted with swimming pools, stables, ponds and miles of bicycling trails. The golf course fairways make a horizontal break through the towering ponderosas; many of the trees are over one hundred years old.

In the early 1970s, a group of young men from Brooks Resources Corporation turned a meadow into their vision. There are several special features about this 1,800-acre complex, not the least of which is that the entire project is owned and managed by the people who purchased the home sites. Each homeowner has an undivided

and equal share of every amenity within the ranch boundaries. That includes nineteen tennis courts, two golf courses, stocked lakes, swimming pools, stables, a recreation barn plus bike, jogging, and cross country ski trails. One of the main goals is to keep Black Butte Ranch a quiet, commercially undeveloped area, a place where people would like to retire. The full-time residential rate has increased each year.

• *Eagle Crest Resort*—Out on the rugged High Desert, off Highway 126 between Redmond and Sisters, is Eagle Crest Resort. The folks who manage Central Oregon's newest destination resort like to call it "a year-round sun spot offering affordable luxury." Construction began at Eagle Crest in 1985, and the second phase started in 1996. Unlike Black Butte Ranch, the majority of the 351 living units are vacation rentals with only a handful of residents calling Eagle Crest their full-time home. Sprawling around the ridges and rimrock, the resort takes advantage of the High Desert climate with two golf courses (the original course was designed by Bunny Mason), two indoor and four outdoor tennis courts, a 118-room hotel, restaurant, four swimming pools, exercise facilities, racquetball courts, outdoor sports courts and an equestrian center.

• *The Inn of the Seventh Mountain*—Opened in 1970, the Inn is one of the area's first resorts. Fourteen miles from Mount Bachelor on Century Drive, it is the closest resort to the ski area. Once a winter destination resort where visitors came for quiet weekends, it is now a year-round destination with a plethora of recreational activities. Condominiums dot the timbered ponderosa forests, and some units boast a view of Mount Bachelor. A summer program that once consisted of five, three-speed bicycles, a small tennis program and stables now features two swimming pools, 65-foot water slide, ice skating rink—converted to roller blading rink in the summer—horseback riding, tennis, camps and programs for kids, and canoe, patio boat and rafting trips on the Deschutes River. One of the licensed Deschutes River white water outfitters is headquartered at the Inn; riding the churning waters of this river is probably the most popular summertime activity. Widgi Creek golf course, a semi-private 18-hole, Robert Muir Graves–designed course is available to Inn guests. While its skiing roots still draw a winter crowd, July and August are the most popular months. Once discovered, the Inn recalls visitors regularly—from sixty-five to seventy percent of the Inn's guests are returnees.

The Inn is owned by the condominium owners, and day-to-day management is done under contract with Capitol Hotel Group International. There are twenty-three condominium buildings with 380 rooms, a main convention center, cafe and restaurant.

• *Kah-Nee-Ta Resort*—Eleven miles north of Warm Springs east of Highway 26 is the stunning Kah-Nee-Ta Resort. Owned by The Confederated Tribes of the Warm Springs Reservation, it stands along the bluff overlooking the Warm Springs River. The setting is truly majestic, and a stay at Kah-Nee-Ta is known for its tranquillity. The main lodge, constructed in the form of an arrowhead, sits on a ridge above the Warm Springs River. The vista, with its ever-changing palette of color painted by the sun, captivates visitors.

The resort also offers facilities for recreational vehicles and camping complete with tipis. Traditional salmon bakes, fishing, kayaking, horseback riding, hiking and golf along with the naturally heated swimming and soaking pools make this a complete yet secluded destination spot.

In 1995, the Tribe leaders voted to add a gaming casino to the resort. The 25,000-square-foot Indian Head Gaming Center features 465 slot machines, four keno stations, two poker tables and six blackjack tables. The resort complex is an important part of the reservation's current history.

• *Mount Bachelor Village Resort*—Perched along the rimrock of the Deschutes River on Century Drive is Mount Bachelor Village Resort. Within the city limits of Bend, it is a smaller, but expanding, resort with condominiums and townhouses. The first 128 Ski House con-

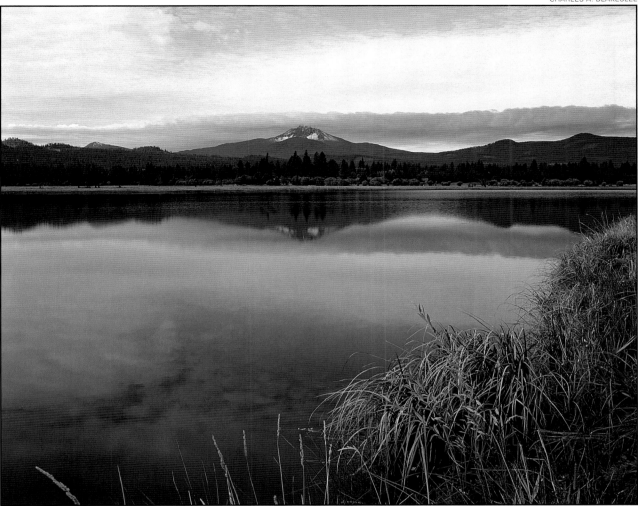

MOUNT WASHINGTON VIEWED FROM BLACK BUTTE RANCH.

dos were built in 1971-72. In 1990 River Ridge, a second complex of stunning condominiums and townhouses was started, and expansion of these units continues. In 1993, construction began on twelve luxurious River Ridge Townhomes that were completed in 1995. The resort has six tennis courts, a year-round pool and spa and river nature trails. It is situated next to the new Athletic Club of Bend, whose facilities guests and owners can use for a fee. Mount Bachelor Village Resort does not have its own golf course, but offers a discount at a nearby golf course.

• *Sunriver Resort*—Once the home of the U.S. Army's Third Engineer Replacement Training Center, Sunriver is now Central Oregon's largest destination resort. Some of the foundations of old Camp Abbot buildings remain, but the main legacy from the days as a training camp is the majestic Great Hall, once the camp's Officers' Club. After the Army abandoned the camp, the land and buildings were used for everything from cattle barn to movie set. Developers renovated and enlarged The Great Hall, and today it serves not only as the center of Sunriver, but also as a venue for a summer concert series and other entertainment. The Sunriver Nature Center, open to the public, provides interpretive programs, a botanical garden, geology trails and natural history exhibits, and an observatory featuring a 12.5-inch reflecting telescope.

Fifteen miles south of Bend, the 3,300-acre maze of homes and condominiums, is both a

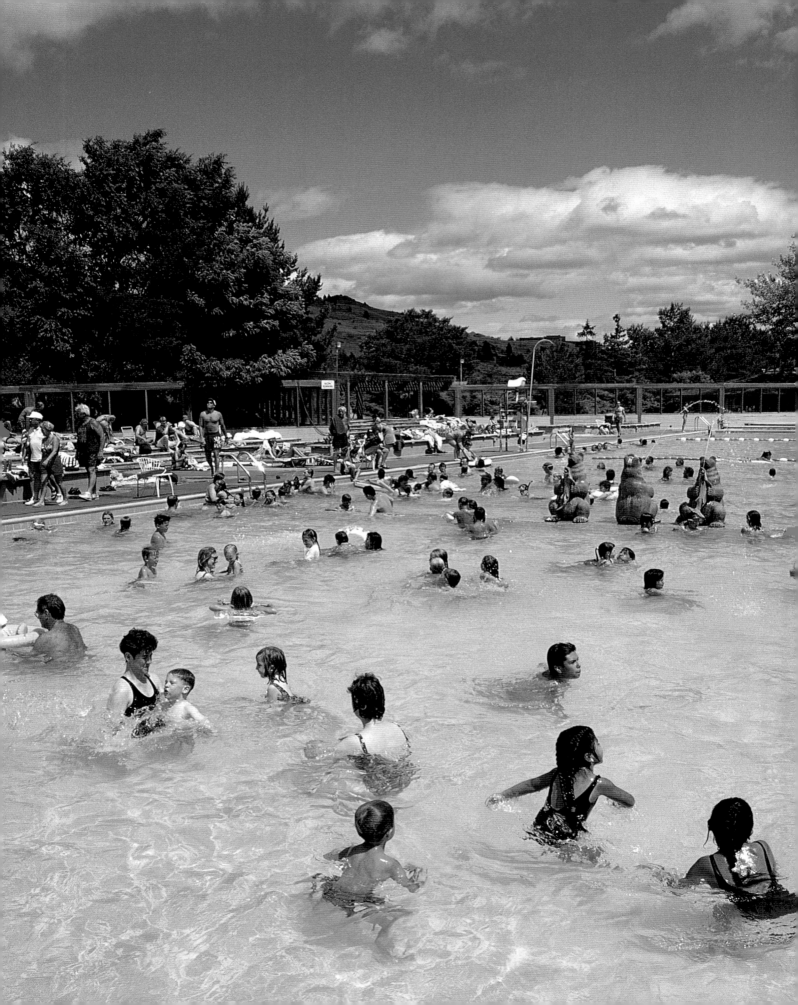

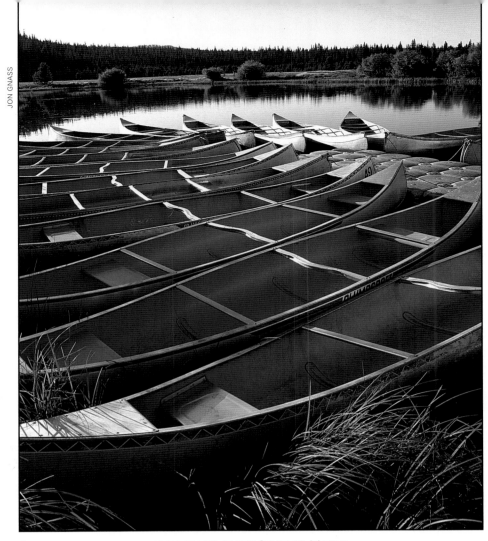

PART OF A SUMMER AFTERNOON CROWD AT THE SUNRIVER MARINA.

destination resort and residential community. There are 3,224 single family lots, with buildings on three-fourths of them. Nearly all of the 895 condominium units are completed. About 1,500 families call Sunriver their year-round home, and have a tight-knit community. The Homeowners Association, resort operators, and real estate interests all work together to meet the varying needs of the community. Sunriver has its own police, fire, and ambulance services plus an airstrip operated by the resort.

Sunriver Resort's three highly regarded, 18-hole golf courses continue to draw accolades. The newest, Crosswater, designed by Robert Cupp and John Fought, ranked first among all new resort courses nationwide in *Golf Digest*'s 1995 evaluations. "As a golf course, Crosswater is a must-play," the magazine said. "As a microcosm of central Oregon, Crosswater is a must-see—expertly integrated into pine forests and wetlands and taking advantage of gorgeous mountain backdrops. And a river runs through it," the magazine concluded. Sunriver Resort offers something for everyone: access to eight miles of Deschutes River for canoeing, rafting, and fishing; the Northwest Golf Digest Golf School; twenty-eight outdoor tennis courts; swimming pools; covered ice skating rink; a lodge and small commercial area with restaurants and a fully equipped conference center. It is a complete vacation experience for those who like to stay put. Of course, come winter, there is easy access to Mount Bachelor Ski Area.

FACING PAGE: THE POOL AT KAH-NEE-TA RESORT, WARM SPRINGS. FRED PFLUGHOFT

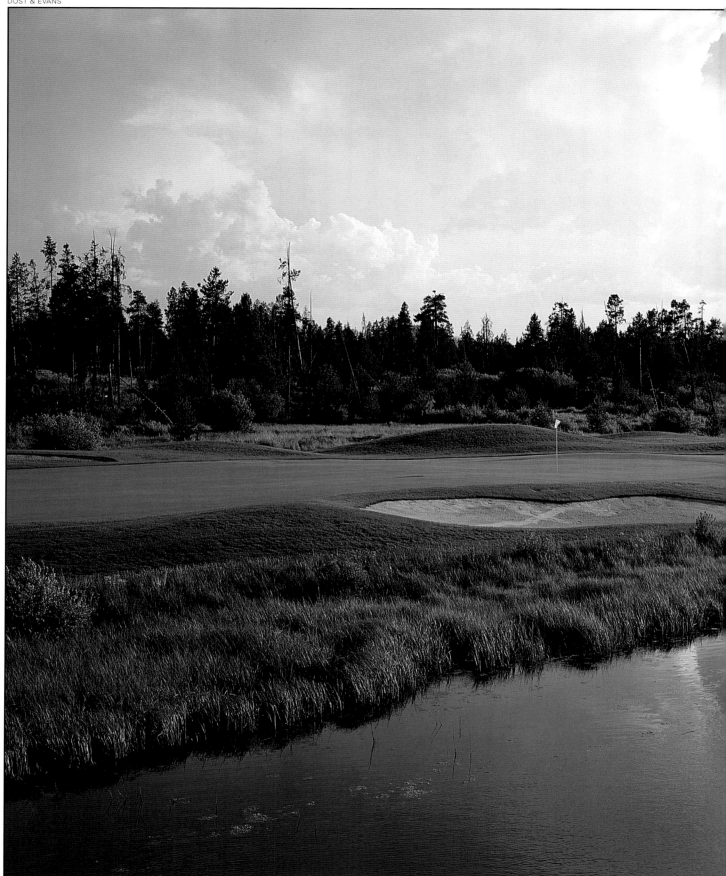

THE 18TH HOLE AT CROSSWATER, LABELED A "MUST-PLAY" COURSE BY *GOLF DIGEST*.

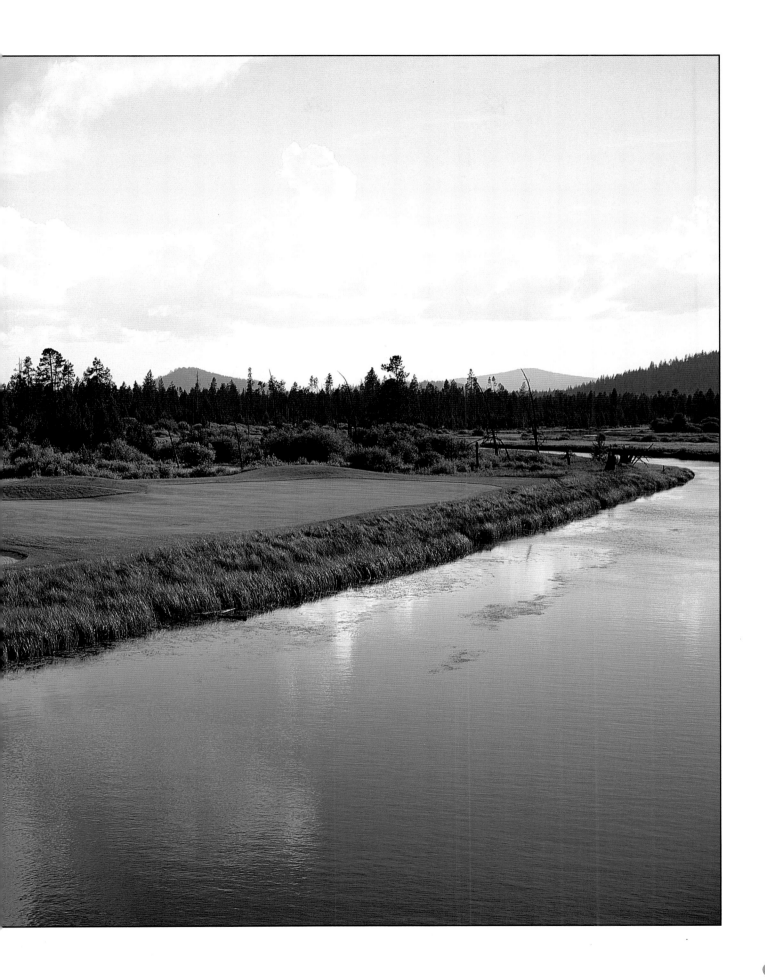

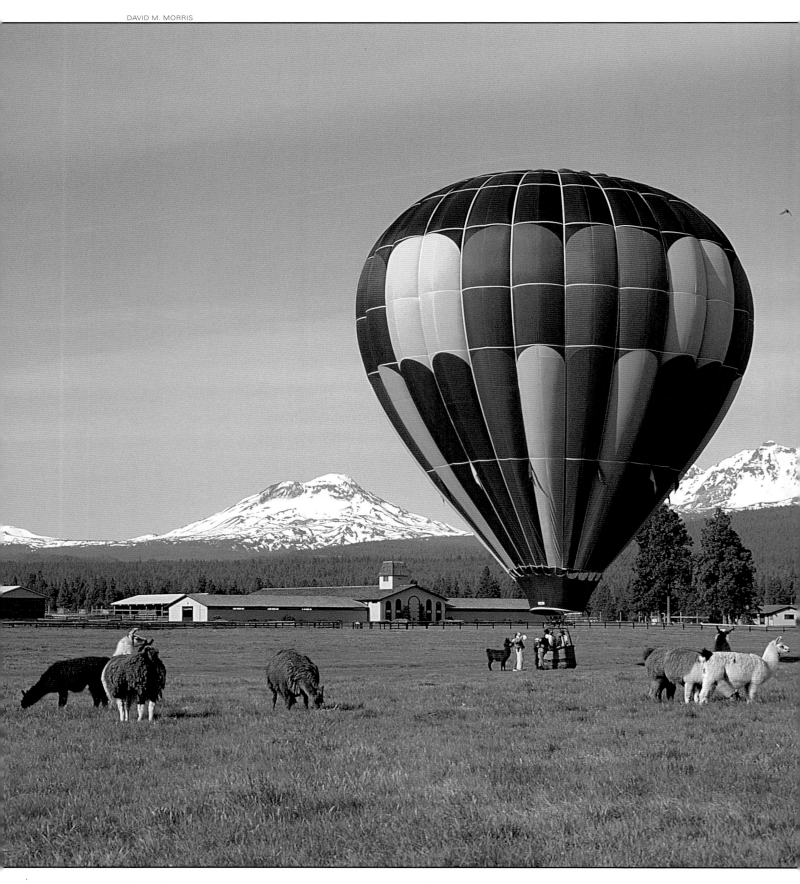

ABOVE: LLAMAS ARE DOCILE, FRIENDLY CREATURES; THEY DON'T EVEN MIND A HOT-AIR BALLOON IN THEIR MIDST.

FACING PAGE: A RANCH NEAR SISTERS IS AMONG THE REGION'S LARGEST LLAMA PRODUCERS.

DAVID M. MORRIS

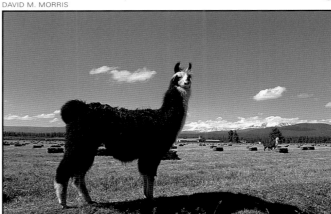

Love affair with llamas

Kelty gave a look that only a llama can. His long neck stretched up like a periscope. His eyes, naturally protruding, surveyed the scene. His ears twitched as he took in the chatter. Two one-gallon tanks of water weighing about thirty-five pounds and filled with fingerling brook trout hung from his packs: Kelty was ready to roll. Workers from the Oregon Department of Fish and Game were loading about twenty-five llamas, all from the Central Oregon Llama Association, for the annual fish stocking of the eastern Cascade Lakes. Toni Landis, llama breeder and advocate since 1980, gave me the rope and a few pointers on leading llamas, and we were off for a three-mile trek to Dorris Lake off Cascade Lakes Highway. Since 1992, llama owners have volunteered their time and animals for the annual fish stocking project.

Llamas are a Central Oregon love affair. Members of the camelid family (along with the smaller alpaca), the North American llama population was extinct by the end of the Ice Age. They are definitely on the rebound. In the United States and Canada, there are an estimated 74,000 to 77,000 llamas. About 9,600 llamas were being raised in Oregon in one recent year and Deschutes County had the highest concentration with about 2,000. The Central Oregon Llama Association has 150 enthusiastic members. Prices for male llamas start at $500, while females cost from $2,500 up depending on quality, bloodlines, and the market. If you have a small acreage, a love of animals, and an interest, you can raise a llama.

What for? Llamas and alpacas are a big business, especially in Deschutes County, where they rate second behind beef cattle in livestock commodity sales. Large ranches like Kay Patterson's Hinterland Ranch in Sisters raise them for breeding, show, fiber and packing. They also make excellent guard animals for sheep herds. Their wool is grease-free, lightweight, warm and luxurious. Artists, weavers, spinners and manufacturers covet the wool.

Llamas are popular pack animals that can carry from eighty to one hundred pounds

of gear, or twenty-five percent of their body weight. As they trek through the forests and mountains, it is difficult to find a print from their two-toed, soft-pad feet. Rather amazing, since each animal weighs between 300 and 450 pounds. The minimum impact to the environment from llamas also includes their diet. They eat less than a pack horse and are browsers, who like to feed on pastures and hay. Their owners supplement their diets with vitamins, minerals, and salt.

Besides packing for man, llamas themselves are easy to transport. They ride in trucks and trailers, and have been known to climb into the back of a small station wagon and lie down.

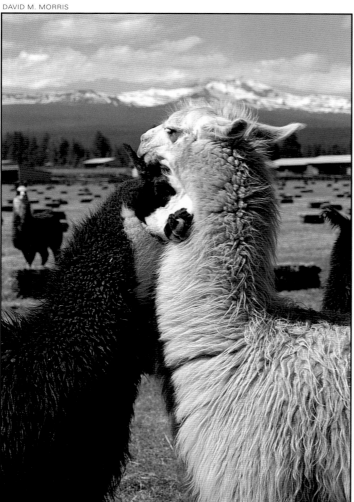

DAVID M. MORRIS

LLAMAS ARE VALUED FOR BREEDING, PACKING AND FIBER.

Many a llama owner has a picture of their favorite animal in the family living room. Every llama has a name.

Llamas live twenty to twenty-five years, so it's easy to get attached. They have no upper teeth, so they don't bite and, when highly provoked, they spit at each other. They have uncommonly good hygiene and use communal dung piles.

Llamas can be trained and cared for without major equipment or physical strength. In a world where livestock is raised for slaughter, the attachment and affection for llamas is more like that for the family dog. Llamas are used for show with dozens of festivals, conferences, and expos held each year. They also make the rounds of parades, schools, and senior centers. The Cascade Llama Lovers 4-H club involves about twenty kids and thirty llamas from the region. Besides monthly meetings, the kids take part in four to eight major shows, go on pack trips, and take spinning classes.

Female llamas are a busy bunch. An average female will first be bred between fourteen to eighteen months and again two to four weeks after giving birth. The average gestation is eleven and one half months. The babies, crias, weigh between twenty- and thirty-five pounds and usually stand and nurse within ninety minutes of birth.

A female llama will give birth to about fifteen crias in her lifetime. The males can be gelded if not used for stud. Most packing llamas are males.

Which gets us back on the trail from Dorris Lake. Kelty was a perfect gentleman. The tiny fish swam out of the plastic bags into the two lakes with a remarkable one-hundred-percent survival rate. Back at the trail head, it was barbecue time for the humans and rest time for the llamas.

"It's so nice to see so many good-looking boys," said Toni Landis, as she surveyed the group. The reference was to the llamas, not the men.

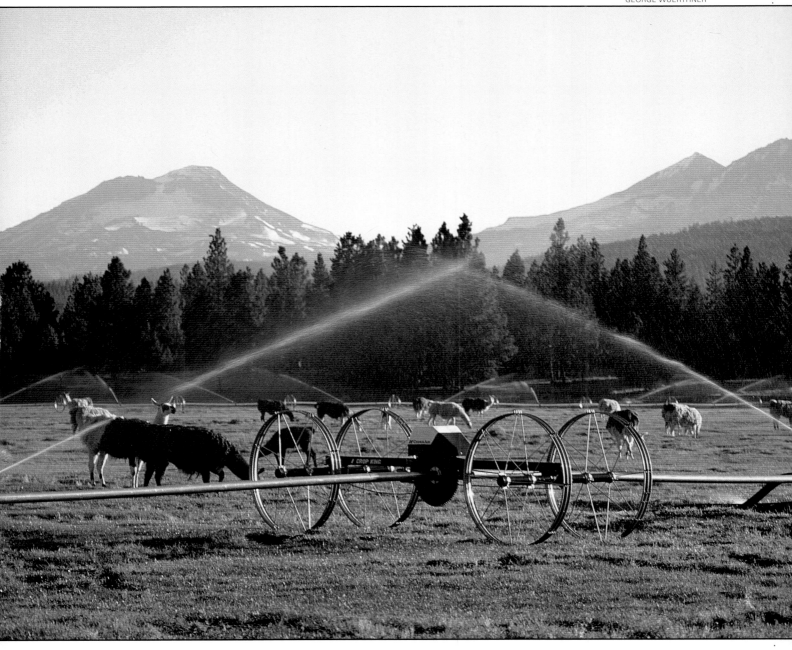

LLAMAS GRAZE NEAR SISTERS, UNRUFFLED BY SPRINKLERS.

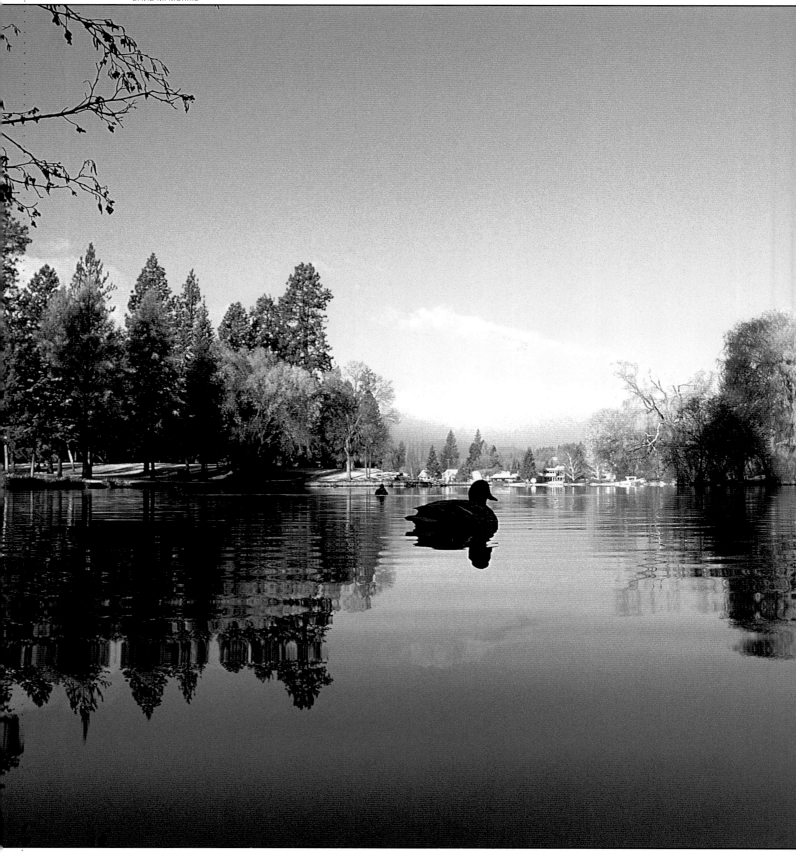

ABOVE: A DUCK PROVES MIRROR POND IN BEND APPROPRIATELY NAMED.
FACING PAGE: NEW HOMES IN AWBREY BUTTE IN BEND.

LYLE COX

Growth, development, and the workforce

Central Oregon knows the roller coaster ride of boom and bust. Between 1910 and 1920, Bend, for example, was one of the fastest-growing cities in the United States. Fueled by the timber industry, it changed from a burg of a few hundred to a bustling town of more than 5,000 population. Things more or less followed the national trend, then another boom hit the region in the 1970s. As quickly as things went up, they came down, and the area's economy plummeted during the recession of the 1980s. The first half of the 1990s brought another boom.

Central Oregon, already the state's fastest-growing region in the first half of the decade, will continue on that track, according to a study by Portland State University's Center for Population Research and Census School of Urban and Public Affairs. The state population will grow by 18.1 percent between 1990 and 2010, according to the Center's study. In the same period, Central Oregon's population will balloon by 34.5 percent.

Once the destination of retirees, the area now is drawing a younger crowd. Many are well educated, and in the age of telecommunications, they have packed up their small businesses and settled in. The cost of living in Central Oregon may be a special attraction to Californians. Bend's cost of living, although slightly higher than the national average recently, is still about two-and-a-half times less than that in California. There are families everywhere, nearly doubling the students in various school systems over the past ten years.

But where will they all work?

The influx of people drawn to the area for its quality of life has changed the workforce. Deschutes County once was predominantly blue-collar; now almost nineteen percent of its residents have four-year college degrees compared with the national average of nine percent with degrees. Yet, in 1993, the average annual wages here were $2,000-$3,000 below the state's average. Many former mill jobs paid well.

Lower-paying service jobs now employ more than 10,000 of the 66,000 workers in the tri-county region. Still, there's big money in the juniper-covered hills. Income from dividends, interest, and rent more than doubled in Deschutes County from 1981 to 1991.

Interesting and well-paying jobs are still available in the area, primarily in industries related to timber and agriculture, especially wood products, along with tourism and recreation. The St. Charles Medical Center in Bend is the single-largest employer with about 1,100 workers. Other major employers are the Bend-LaPine School District, Bright Wood Corporation, Advanced Power Technologies, Les Schwab Tire Distribution Center, Bend Millwork Systems, and Tektronix Incorporated.

There has always been an entrepreneurial spirit in the clean, crisp air. Few know that the Continental Trailways bus system began in Bend in 1929, but everyone knows about Les Schwab. It is a Central Oregon rite of passage to get your first set of studded snow tires come November. If you go to a Les Schwab Tire Center, you know why Schwab's tire service and distribution business is just about legendary. In 1952, Schwab bought O.K. Rubber Welders in Prineville. Still headquartered there, he has built the largest independent tire business in the United States with an initial $3,500 investment. There are now over 250 company stores or member dealers in Oregon, Washington, Idaho, Northern California and western Montana that employ 4,000 people. The firm has 550 employed in its Prineville headquarters and its new, 450,000 square-foot distribution center. Schwab's philosophy of small stores with excellent service and a profit-sharing program has panned out. The company adds ten stores a year.

As light industry grows, the combined jobs from tourism boom. Of the region's top forty employers, approximately 2,400 jobs are from the ski area and destination resorts. Add to that the motels, restaurants, shops, Forest Service and park employees, and recreation is of major economic importance. According to the Oregon Economic Development Department, more than $236 million comes into the Central Oregon economy each year through tourist dollars. Serving the recreational needs of the population and tourists is only part of the employment picture.

Companies like EntrePrises USA, a subsidiary of a French firm, manufactures rock climbing walls and holds for world-wide distribution. The Bend company employs thirteen to seventeen workers. Metolius Mountain Products is another spin-off of rock climbing. Founded in 1984 in tiny Camp Sherman, Metolius Mountain Products moved to Bend and now employs fifty workers making just about everything for climbers except the shoes and nerves of steel.

Some companies move their entire operation to Central Oregon for the quality of life and economic climate. SeaSwirl Boats, makers of fiberglass family pleasure boats, did just that. Eighteen years ago, the company president relocated the whole outfit to Culver, nine miles from Madras, after vacationing in the area. Today, SeaSwirl, a subsidiary of Outdoor Marine Corporation, manufactures 2,200 boats a year and employs from 145 to 225 people.

Promoters of new business in Central Oregon like to point out the low rate of employee turnover and the diversity of the workforce. Business promoters also emphasize that people live here because this is where they want to stay.

Unemployment in Central Oregon was almost the same as the national average in one recent year, down dramatically from the rate thirteen years earlier. That year, 1982, the word "traffic" meant the stream of U-Hauls exiting Bend, said Carol Woodard, executive director of the Central Oregon Economic Development Council (COEDG). The council is one of a dozen business support organizations that either markets and promotes the tri-county region as an employment base, or offers economic resources and employee training programs. Founded in the early 1980s as an offshoot of the Bend Area Chamber of Commerce, the council works on gathering data and resourcing, partnership programs, and

BROKEN TOP CLUBHOUSE.

marketing Central Oregon. The office receives about 1,200 phone and mail requests from potential businesses each year and works an active client database of 125.

An innovative alliance with Central Oregon Community College and the business community spawned the Business Development Center and the Oregon Innovation Center. The Business Development Center offers consulting, incubator space, a resource center and training to small businesses. "Our focus is on existing companies being well run," said Bob Newhart, the college's business development director. The idea is that a well-run operation is a healthy one, and healthy businesses will naturally grow creating well paying jobs. Fees are affordable from free short-term counseling to low-cost workshops.

The Business Development Center counsels as many as 500 clients a year and is financed by client fees and money from the college, the state lottery, and the federal Small Business Administration. The client list is as varied as the landscape.

Nomadics Tipi Makers, outside Sisters, makes individually designed tipis. In the late 1960s, Jeb Barton and his brother headed west in search of personal growth and education.

DRAKE PARK IN BEND MEMORIALIZES THE MAN CREDITED WITH FORMALLY ESTABLISHING THE CITY.

During part of that period, they lived in a tipi. What they found was a remarkable dwelling that offered more than shelter. In 1970, they set up a cottage industry. Jeb Barton bought out his brother in 1975, and today Nomadics Tipi Makers creates a line of tipis from those with eight-foot-diameter floors for kids to twenty-six-foot dwellings. Barton designs, cuts, and sells for the mail-order business and contracts independent seamstresses for the sewing.

Since 1970, Nomadics Tipi Makers has created 12,000 tipis, including some for the movie *Dances With Wolves*.

Central Oregon is becoming a mecca for small high-tech firms.

Mini Mitter, short for miniature transmitter, moved its operation from Indiana to a home office in Sunriver in 1987. Today, the company creates physiological monitoring equipment for medical research from a new 7,000-foot facility in the Sunriver Business Park. Mini Mitter's main emphasis is on implantable transmitters for use in biomedical animal research. A new product line includes wearable (non-invasive) physiological data loggers that monitor temperature, heart rate, and activity in humans. Mini Mitter has a long-running association with the Business Development Center (BDC).

"The quality of living is exceptional in Central Oregon. We have no difficulty getting in touch with our clients and customers. On balance, with the quality of life it's terrific," says

Denny Ebner, chief executive office of Mini Mitter.

What makes a huge impact on the success of the BDC is the incredible resource of early retirees, a network of bright and educated business people, who share their time and expertise. "You just don't have that everywhere," notes Newhart. "That and a very skilled labor force."

The Oregon Innovation Center, housed in a temporary space awaiting completion of its new 10,000-square-foot building at the airport in Redmond, is a teaching center focusing on technology companies. Here, business plans are taken from an idea to the market place. Founded in 1989, the Oregon Innovation Center offers sophisticated access to information from data base searching, teleconferencing via satellite, interactive instruction, and links to academic research. Plans for the facility include incubation and support services for small tech companies and laboratory space for research and development.

Promoters of Central Oregon are targeting smaller businesses that are both environmentally and economically sound. COEDC focuses on five areas: software and information technology, recreation equipment, secondary and finished wood products, aviation and aerospace and agricultural equipment and value-added processing.

Many of these organizations work in tandem with the Oregon Economic Development Department (OEDD). Central Oregon is one of the state's twelve designated economic regions and it benefits from state lottery revenue earmarked for business development.

The region wasn't founded on "city slicker" jobs. Central Oregon has a rich history of farming and ranching. By 1912, the High Desert was populated with ranchers taking advantage of the grasslands, and farmers hoping to turn the parched terrain into another Palouse Valley. Wars between sheep and cattle ranchers once raged, and the wrangling over water and irrigation made some wealthy and others bitter and defeated.

Agricultural land is owned and managed both privately and by the U.S. Forest Service and the federal Bureau of Land Management. Beef cattle has been at the top of the agricultural products in the tri-county area along with alfalfa and other hay crops, vegetable seeds, peppermint and farm forest products. For Central Oregonians, the late-summer mint harvest is an olfactory delight.

FRED PFLUGHOFT

GOLFERS AT WIDGI CREEK GOLF COURSE, BEND.

Sheep ranching, once of major importance along with potato farming, declined about the time of World War II. In Deschutes County, cattle and calves are the largest agricultural commodity with llamas and alpacas second. Now vegetable seeds like garlic, carrots, radishes and coriander fill the fields in Jefferson County. Besides mint and alfalfa, Crook County is developing a thousand acres of sugar beets in its crop mix.

As so often happens, commercial, industrial, and residential growth fills the fields where crops or grazing land once reigned. Between 1982 to 1992 more than 20,000 acres of agricultural land was turned into housing developments, shopping centers and parking lots. Each county has zoning regulations to protect farm land, but protection and free enterprise often conflict. Through compromise, factories, resorts, and homes necessary for growth are built. A huge chunk of land in Central Oregon is owned by the state or federal govern-

ment and the best use of that land continues as a hot topic of debate.

Central Oregon has been in a "building boom" since the late 1980s. In the most recent year for which figures were available, there were nearly 1,000 building permits for new homes in the three counties.

Homebuilding has created a healthy construction trade. Building and real estate help drive the economy. Title companies in Deschutes County are constructing new buildings at a startling pace, and banks boast healthy portfolios, much of it based on mortgages and construction loans. There are eighteen financial institutions in Central Oregon.

The Bank of the Cascades, the first independent bank in Central Oregon, was established in 1975. Today, with its headquarters on Wall Street in Bend, it has eight branches. Held by Cascade Bancorp, it was the first business headquartered in Bend to be publicly traded on the open market.

JON GNASS

BALING HAY NEAR SISTERS.

Regionally, 3,000 workers were employed in the construction industry in 1991. There are about 1,000 real estate agents and 175 offices affiliated with the Central Oregon Board of Realtors, but the area's real estate market often reflects the California economy. Fifty-four percent of those who moved to Central Oregon since 1989 were from California.

If you asked most Central Oregonians to name one real estate development company, it would likely be Brooks Resources Corporation. The brush stroke of the former subsidiary of Brooks-Scanlon Inc. is broad. At one time, Brooks-Scanlon, one of the two major mills in Bend and the largest employer, owned 250,000 acres of land, including its timber interests. In 1953, it bought out Shevlin-Hixon mills and set out to diversify the area's economic base. Brooks Resources Corporation was founded in 1969 to develop the companies' properties.

Brooks Resources, now privately held, has been a pace-setter in regional development: Black Butte Ranch, two subdivisions outside Sisters, Bend's high-end residential communities of Awbrey Butte and Awbrey Glen, with its own golf course, a business and light industrial park in Bend, Shevlin Center, and a condominium and second-home resort and small business complex on the Deschutes River in Bend, Mount Bachelor Village.

Michael Hollern, president and chairman of the board of Brooks Resources Corporation, says he is particularly proud of the Black Butte Ranch project. "It was something completely new, there was more risk. Now we've seen it mature and develop."

Whether high-end housing has been over-developed in Central Oregon, particularly Deschutes County, is a community concern. Homes over $150,000 can easily stay on the market for a year. The idea of higher density, smaller lots, and old-fashioned neighborhoods is the current fashion in Bend. Like other developers, Hollern and his company work with

local government and citizen groups to compromise differences over development. When Brooks Resources began real estate development, it was the only big game in the area. Competition now comes from developers of Eagle Crest west of Redmond, Broken Top west of Bend and Mountain High, south of Bend, and others.

Everyone who moves to Central Oregon seems to want to close the gate. Of course, that's nothing new. When Alexander Drake moved to Bend at the turn of the 20th century, there were those who vehemently opposed his initial development plans.

The majority of the Brooks Resources work has been in residential development, but it owns considerable tracts of commercial property. The 200-acre Shevlin Center on one-time mill property is one of its first commercial-industrial projects. Running along Colorado Avenue are the grassy parkways, flower beds, sidewalks and a new bridge; public jogging trails hug the river. Businesses in Shevlin Center include ORCOM Systems, Nosler Bullets Incorporated and state offices of the Motor Vehicle Division and the Oregon National Guard Armory.

"What we have there is the nicest street in town," said Mike Byers, a Bend city planner.

No place seems immune to growth. Jefferson County, with a projected population of 16,238 people in 1995, runs neck-and-neck with Deschutes as the fastest growing of the three counties. Towns within the county like Madras have an enterprise zone and business incubator space. Business promoters in Madras consider as ready-made incentives the 8,000-foot runway at the Madras Airport and an artesian spring that already supplies domestic water for the Deschutes Valley Water District and two bottling plants in Culver. The third-largest employer in the tri-county region, Bright Wood Corporation, is based in Madras.

Development doesn't always need a town. Take Crooked River Ranch in southern Jefferson County between the Crooked and Deschutes river canyons. In 1971, Bill MacPherson bought some of the most spectacular land in the county from the Thomas Bell family, who had owned the property since 1961. MacPherson planned to make it a recreation site. After his death, it was rezoned in the early 1980s to rural residential. The Crooked River Gorge plummets to the east and the Deschutes River cuts to the west. In 1995, it was home to over 2,500 permanent residents, two recreational vehicle parks, a beautiful 18-hole golf course, pool, tennis courts, local saloon and restaurant, rodeo arena, church and real estate office.

The 12,000-acre development is subdivided into lots usually between two and five acres. It is unincorporated and operates under jurisdiction of Jefferson and Deschutes County governments, and a homeowners' association. What makes it unusual is that about eighty percent of the structures are manufactured homes. The sight of hundreds of manufactured houses and mobile homes perched on the remarkable rimrock and valley of the gorge can be unsettling. This may be the only place in the country where a manufactured home works as a bed-and-breakfast.

Yet to the residents of Crooked River Ranch, who are dealing with growth like the rest of the region, it offers affordable homes in a spot usually reserved for the rich. "As you can see, this is no Sunriver," states the general manager, Ginger Morrison. "The attraction is the rural community feeling, low-key lifestyle, and affordable housing."

While those at the reins of planning and development for Central Oregon struggle with just how to meet the housing and employment needs of such a diverse group, it is certain that almost everyone agrees on one thing: They want to retain what they all live here for—clean air, outdoor activities, low crime, natural beauty and a sense of belonging.

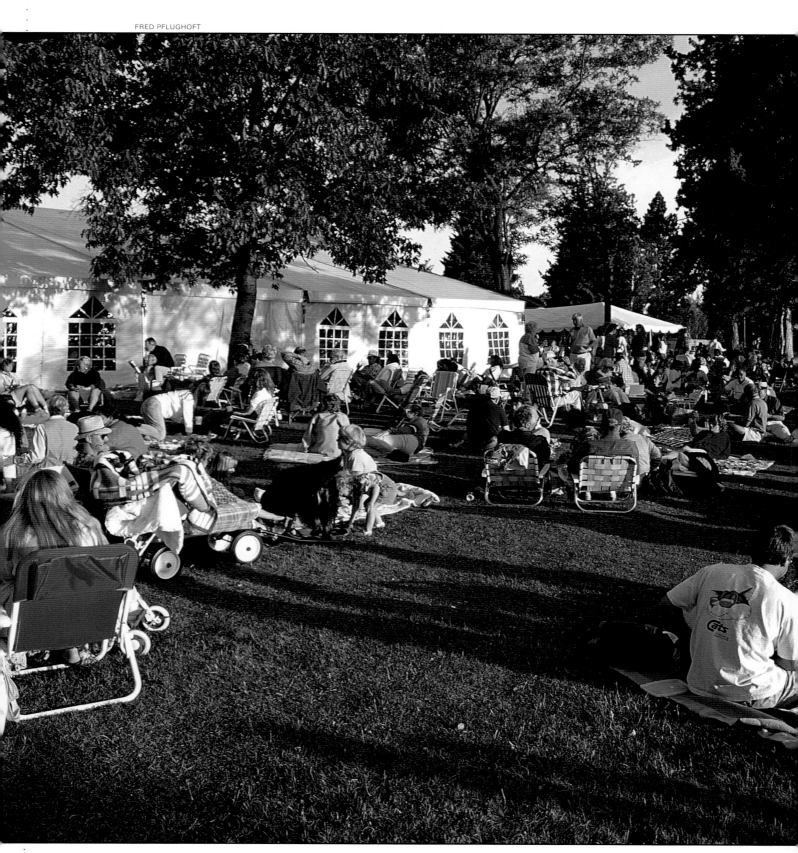

ABOVE: THE ANNUAL CASCADE FESTIVAL OF MUSIC IS A SUMMER TREAT IN BEND.
FACING PAGE: THE HIGH DESERT MUSEUM IN BEND.

LYLE COX

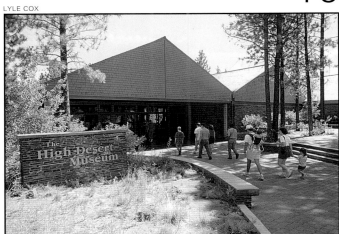

People and the culture

There is always more to the story; for this region it is the people and the culture they have created. There are still cowboys making a living as ranchhands. There are people who know the seasons not by the changing climate or ski conditions, but by their varied hunting permits. And more than a decade ago, there were thousands of followers of Bhagwan Sri Rajneesh, who turned the little town of Antelope, Oregon into a media circus.

There are artists and authors, naturalists and thinkers who eke out a living, and those whose dreams become a reality, none more successfully than Donald Kerr, who had an idea for a museum. That idea is now the High Desert Museum on a 150-acre site three and a half miles south of Bend off Highway 97. The Museum opened in 1982 and today is a model for "living museums." The stunning slate, wood, and lava rock structure turns itself inside out, offering informative and emotionally touching experiences within its walls, and outside in the natural habitat, as well.

The Museum's regional focus includes the Columbia Plateau to the north, the Rocky Mountains to the east, the Colorado Plateau to the south and the Cascade Range to the west. Inside the building, the Earle A. Chiles Center on the Spirit of the West exhibit recreates the world of the settlers, explorers, and Native Americans. Perfectly appointed dioramas built along a winding, softly lit walkway offer an almost voyeuristic experience. Step outside, and it all comes to life with nature paths taking you to a working sawmill set in the second-growth pines or a sheepherder's wagon in a grove of aspen.

Kerr's dream was to create an environment that not only showed the past, but also challenged people to look to the future. This cross-disciplinary approach and the idea that people need to experience a museum drove the young biologist, who never lost sight of his goal. It was a live-and-learn experience for Kerr, who took the models of two museums—the Arizona Sonora Desert Museum near Tucson as the natural

A NATURALIST TEACHES ABOUT SNAKES AT THE HIGH DESERT MUSEUM.

history model, and the Provincial Museum in Victoria, British Columbia as the cultural model—to help solidify his vision.

Of course, it took more than vision to create this dream. Kerr presented his proposal to Michael Hollern, then head of Brooks-Scanlon Incorporated, the giant forest products company. Hollern initially turned Kerr down, but Kerr fine-tuned his business plan and went back to try again. Eventually, Hollern gave Kerr an option on 150 acres of land south of Bend worth about $200,000. It was his if Kerr could raise the like amount of cash. Within a year, he did. Today, Hollern is a staunch supporter of the museum and is past president of its board of trustees.

The museum has expanded with the completion of the outdoor Otter Exhibit, a Desertarium, an education center with theater, resource library and classrooms plus a gift shop and cafe. A climate-controlled gallery houses Western art and artifacts. A $15 million expansion, the Henry J. Casey Hall of Plateau Heritage, was planned, principally to house 3,000 Native American artifacts from the museum's Doris Swayze Bounds Collection. Fund-raising also was launched to construct a Birds-of-Prey Center and to stabilize the museum's financial health.

Turn from the desert to the mountains and see another man's dream-come-true. Bill Healy, a veteran of the Army's Tenth Mountain Division during World War II, looked at Mount Bachelor and saw ski slopes. In 1958, Mount Bachelor Ski Resort opened. Healy, who died in 1993 of complications from a neuromuscular disease, always looked beyond the mountain to the community that sustained it. The Bill Healy Foundation provides generous financial support to local causes. Each spring the ShareLift fund-raiser gives discounts on lift tickets and proceeds to the foundation. The Bill Healy Family Housing Center

opened in 1995, and ShareLift revenue that year was contributed to the cost of renovating Bend's Amateur Athletic Club building into a Boys and Girls Club.

Healy's widow knows what extra trait made her husband special. "He was a visionary," she said. Healy is a local folk hero, a man who only wanted a place to ski with friends and family and one who could bring out the best and brightest ideas from those around him. He continued to ski, to push, to build even as disease ate away at him.

It escapes almost no one who takes to the slopes of Mt. Bachelor each ski season that this is a special mountain. The eye for detail, respect for the terrain and family atmosphere makes other areas pale in comparison. It is a fitting legacy for a man who loved his work and his play.

There are dozens of people who make their mark on Central Oregon. So many, that each year *The Bulletin* puts out a special tabloid section about the region. In one recent year, the *Legacy* section profiled thirty-four Central Oregonians from pioneers to people like Fred Boyle, past president of Central Oregon Community College and Carrie Novick, manager of the Redmond Municipal Airport.

Robert Chandler, editor of *The Bulletin,* is a legend in his own right. In 1953, the young journalist came to Bend with a degree from Stanford University and a decade of news experience, and bought the paper. "There were predictions that the town would go broke," he says from *The Bulletin*'s office. Chandler has seen boom and bust and takes the long view. Tirelessly, he has served at the community, state, and national level on dozens of boards. Since those early days, when Bend was still a mill town, Chandler has been a force in the community. He knows he is not alone: "Let people know that they have a chance to make a difference, and they'll do anything to get involved."

In Central Oregon it's hard to imagine life without the volunteer force that drives it. If you're not willing to take part in these communities, you're just not going to fit in. The people who work for the love of it seem to have a passion about their causes. Joining an organization is rarely a rung on the social ladder, if there even is one.

There are volunteers in the schools, hospitals, Forest Service, hospice and Habitat for Humanity. Volunteers keep the cultural wheels turning and new ideas churning. In 1977, a volunteer group started the Bend Recycling Team and recycled 83 tons of material that year. Seven years later, the team handled 5,731 tons. Thirteen people now are employed by the Recycling Team, all but two of them are full-time.

Local newspapers, besides *The Bulletin* which publishes seven days a week, include Prineville's *Central Oregonian*, published twice a week, and the *Redmond Spokesman* and *Madras Pioneer*, both weeklies. Other publications with news of Central Oregon are the *Cascade Business News*, published twice a month; and *The Oregonian* of Portland. Two local television stations and twelve radio stations also serve Central Oregonians.

A series of classical music performances contributes to Central Oregon's cultural life along with two community theater groups and dozens of other performances. There are six music festivals annually offering a wide range of music. Quilt and craft shows are regular events, including the nationally known Sisters Quilt Show, largest of its kind in the country. There are 152 churches in thirty denominations in Central Oregon. It is a region where people also draw spiritual strength from the natural beauty and strong sense of community.

That sense of community—whether it centers in nature, education, community service or spirituality—is infectious. Newcomers to the region are caught up by the interest, enthusiasm, and commitment residents hold in their towns and communities. It seems that all 125,000 citizens of the tri-county region want a say in its future and have an opinion about its past. Central Oregon, once a babe in the heart of the state, is growing up and everyone wants to be the parent.

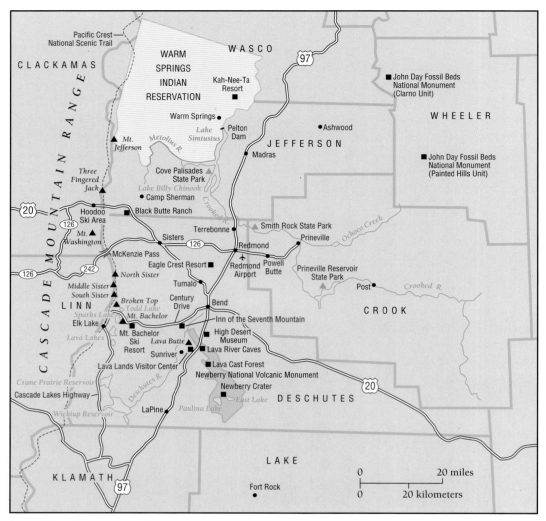

For further reading

Alt, David & Hyndman, Donald, *Roadside Geology of Oregon*, Mountain Press Publishing, Missoula, MT, 1978

Boyd, Robert, *Wandering Wagon: Meek's Lost Trail of 1845*

Brogan, Phil F., *East of the Cascades*, Binford & Mort Publishers, Portland, OR, 1964

Clark, Keith, and Lowell Tiller, *Terrible Trail: The Meek Cutoff, 1845*, The Caxton Printers, Caldwell, Idaho, 1966

Crook County Historical Society, *The History of Crook County*

Deschutes County Historical Society, *A History of Deschutes County in Oregon*, 1985

Dodds, Gordon B., *American Northwest: A History of Oregon and Washington*, Forum Press, Arlington Heights, IL, 1986

Garret, Stuart G., *Newberry National Volcanic Monument: America's Newest National Monument*, Webb Research Group, Medford, OR, 1991

Gulick, Bill, *Roadside History of Oregon*, Mountain Press Publishing, Missoula, MT, 1991

Harris, Stephen, L., *Fire and Ice: The Mountaineers*, Search Pacific Books, 1976

Hatton, Raymond, *Bend in Central Oregon*, 1986; and *High Country of Central Oregon*, Binford & Mort Publishing, Portland, OR, 1987

Hoy, Mark, *Oregon Backroads*, American & World Geographic Publishing, Helena, MT, 1988

Jefferson County Historical Society, *The History of Jefferson County Oregon 1914-1983*, Jefferson County Historical Society, 1984

Orr, Elizabeth L. and William N., and Ewart M. Baldwan, *Geology of Oregon*, Kendall/Hunt Publishing Company, Dubuque, IA, 1974

Stowell, Cynthia D., *Faces of a Reservation: Portrait of the Warm Springs Indian Reservation*, Oregon Historical Society Press, 1987

Teel, Harry, *No Nonsense Guide to Fly Fishing Central & Southeastern Oregon*, David Marketing Communications, Sisters, OR, 1993

Tisdale, Sallie, *Stepping Westward: The Long Search for Home in the Pacific Northwest*, Henry Holt and Company, 1991

Ward, B. Elizabeth, *Redmond: Rose of the Desert*, B. Elizabeth Ward, 1975

Watts, Alan, *Climber's Guide to Smith Rock*, Chockstone Press, Evergreen, CO, 1992

Wing, Raven and Brooke Snavely, *Fishing in Central Oregon*, Sun Publishing, Bend, OR, 1994

Index

Italics indicate illustrations

Christine Barnes lives in Bend, Oregon with her husband, Jerry. They have two grown children, Melissa and Michael Barnes. She is a journalist and writer who has worked for newspapers in Colorado, Chicago, and the San Francisco Bay Area. She was features editor for the Oakland *Tribune* and San Francisco *Examiner*. Christine now writes for a variety of newspapers and magazines. In her spare time, she skis, hikes, travels and enjoys the continuous fun of discovering Central Oregon. Usually at her side is the ever faithful, Shelby.